sand piper - tring
frecuenta las aull
bandadas -

IMAGES
of America

MERRITT ISLAND
AND COCOA BEACH

Aymee D. Paddock
45 Riverview Lane
Cocoa Beach,
 FL 32931
Ph (321) 783-8986

 I bought this book in 2001
 at M.D. FC,

 RSD

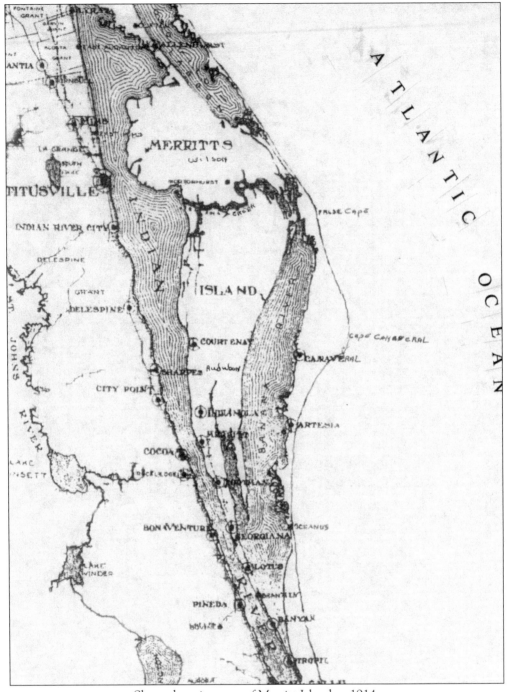

Shown here is a map of Merritt Island, *c.* 1914.

IMAGES
of America

MERRITT ISLAND
AND COCOA BEACH

Ada Edmiston Parrish, Alma Clyde Field,
and George Leland "Speedy" Harrell

ARCADIA

Published by Arcadia Publishing,
an imprint of Tempus Publishing, Inc.
2 Cumberland Street
Charleston, SC 29401

Printed in Great Britain.

Library of Congress Catalog Card Number: 00-110539

For all general information contact Arcadia Publishing at:
Telephone 843-853-2070
Fax 843-853-0044
E-Mail sales@arcadiapublishing.com

For customer service and orders:
Toll-Free 1-888-313-2665

Visit us on the internet at http://www.arcadiapublishing.com

CONTENTS

Acknowledgments 6

Introduction 7

1. North Merritt Island: From the Haulover Canal to Banana Creek,
 Allenhurst, and Wilson 9

2. Banana Creek South: Banana Creek to Highway 520, Orsino,
 Courtenay, and Indianola 17

3. The Merritt City Area 57

4. South Merritt Island: From Highway 520 to Dragon Point,
 Footman, Georgiana, Lotus, Brantley, Banyan, and Tropic 71

5. The West Shore of the Banana River: Audubon
 and Angel City 89

6. The Beach Side of the Barrier Island: Canaveral, Artesia,
 Cocoa Beach, Oceanus, and Patrick Air Force Base 99

ACKNOWLEDGMENTS

The authors wish to thank the individuals and organizations that made this book possible. In particular, three organizations—the Tebeau-Field Library of Florida History in Cocoa, the North Brevard Historical Museum in Titusville, and the Central Florida Mosquito Beaters in Cocoa—were instrumental in the creation of this work. Their friendly volunteers and voluminous archives made a difficult task easy and pleasant.

Various individuals also contributed to this book by supplying never-before-published pictures, recollections of individuals and events, and endless hours of pleasant conversations. They are as follows:

Ann Akridge Bonner
Volamae Roberts Brinkley
Anne Gettings Butler
Mary Ann Prine Feldhauser
Nonie Knutson Fox
Margaret Quintock Funsch
Hal Gettings
June Gettings Geiger
Robert Gould
Amelia Hill
Jane Laird Hill
Fred Hopwood
Marion Paterson Jackson
Betty "Walter" LaRoche
Richard Lindabury

Harriett LaRoche Linnell
Sarah Curtis Williams Nisbet
Margaret Peterson
Frank Pound
Charlie Provost
Florence Holmes Staton
Carol LaRoche Towns
Virginia Washbon
Marlene Minella Wells
Barbara Mueller Williams
Martha Woelk
Debra Wynne

And Don Nead of Village Printers in Historic Cocoa Village

All royalties from this volume will go to the Tebeau-Field Library of Florida History, 435 Brevard Avenue, Cocoa, FL 32922. The Tebeau-Field Library is owned and operated by the Florida Historical Library Foundation, a 501(c)(3) not-for-profit organization. It receives no local, county, or state funds.

INTRODUCTION

The history of Central Brevard County, Florida, is almost as long and complicated as the geographical borders of the county itself. Stretching north and south for 77 miles, Brevard County is a thin strip of land that hugs the shores of the Indian River Lagoon, abruptly halted in the east by the Atlantic Ocean and brought up short by the St. Johns River basin in the west. Although long, the county is barely 10 miles wide at its northern boundary and only 20 miles wide at its southern end. Within these narrow and restrictive confines, however, diverse and dynamic groups of people have left their marks.

The earliest inhabitants of the county were Native Americans, who feasted on the bounty of the lagoon, the St. Johns River, and the Atlantic. When Europeans first explored the area, they found large, high mounds of discarded shells from oysters, clams, and other mollusks. Because of the difficulty in conquering the always-wet environment, Europeans largely ignored the area during the first 300 years of settlement. The abundance of several varieties of bloodsucking mosquitoes also discouraged European settlement. As a result, the Brevard County area was among the last areas of Florida to be brought into the mainstream of Florida's social, economic, and political life. Culturally, the county's inhabitants, cut off from easy access to more "civilized" activities, developed their own entertainment and diversions.

Originally named Mosquito County on the earliest maps of Florida, present-day Brevard County was large and sparsely settled. At one time, the geographical limits of the county stretched as far south as Lake Okeechobee and modern Dade County and as far west as Kissimmee. It included parts of modern Orange, Seminole, and Volusia Counties. Gradually, however, the county's vast size was pared down to create several counties. By 1900, the county had shrunk to its present boundaries. Despite the loss of territory, Brevard County never lost its uniqueness.

It is impossible to capture the diversity of Brevard County in a single book. In 1998, we published *Images of America: Central Brevard County*, which dealt with Cocoa, Rockledge, and the smaller towns in the very center of the county. In 1999, Frank Thomas published a similar book on Melbourne Beach and the small resort towns to the south. The same year, John Manning and Robert Hudson published a pictorial history of North Brevard County. Because of the tremendous size of the county, many areas were, by necessity, given short shrift or ignored entirely. This is an effort to correct that oversight.

Merritt Island is a large barrier island that stretches for 20 or so miles and makes up the eastern shore of the Indian River Lagoon in central Brevard County. Originally settled by hardy pioneers who raised cattle and cultivated citrus, vegetable, and pineapple crops, the island is now a major population and business district in the county. Despite its recent emergence as a

commercial and residential center, there are still large areas that remain pristine and protected. Tucked away in hammocks along the shore, surrounded by million-dollars homes and subdivisions, the careful observer can find large citrus groves, simple homes built by early settlers, and, here and there, the remnants of small communities that once were hubs of activity. Although their original inhabitants are long dead and most, if not all, of their original buildings gone, the names of these early settlements—Orsino, Georgiana, Indianola, Honeymoon Lake—are still attached to the region. Few modern residents even know the origin of the names of their streets or subdivisions, but the "old timers" know and fondly recall the history, personalities, and events that etched these names indelibly on county maps.

Cocoa Beach is a modern city created by the imagination, energy, and enthusiasm of a single man, Gus Edwards. A transplant from Georgia, Edwards was the city attorney for Cocoa. That job paid the bills, but Edwards's real calling was as a dreamer of schemes, a seer of the possible, and as a man of vision. Imbued with the "Boom" mentality of the 1920s, he labored long and hard to sell his vision of Cocoa Beach as a mighty rival to Carl Fisher's Miami Beach resort and to D.P. Davis's artificial Venice in Tampa Bay. Despite setbacks caused by the "Bust," the Great Depression, and World War II, Edwards persisted. With the coming of the space program in the late 1940s and early 1950s, what had been one man's dream became a hard reality. The City of Cocoa Beach moved past the elaborately drawn plats of subdivisions and the few, scattered buildings erected to entice buyers, to the reality of a modern city, complete with homes, stores, resorts, crime, and taxes. Still, there are those who remember Cocoa Beach as it was—a vast area of open beaches, stalked relentlessly by a single man with a consuming vision.

We hope we have captured the historical essence of Merritt Island and Cocoa Beach. We hope that the ghosts of the earliest settlers will be pleased with our efforts. We hope that the spirit of Gus Edwards will be satisfied that we have done his dream "proud." Most of all, we hope the reader will enjoy this book as much as we enjoyed putting it together.

Ada E. Parrish
A. Clyde Field
George "Speedy" Harrell

July 2000

One

North Merritt Island:

From the Haulover Canal to Banana Creek, Allenhurst, and Wilson

Merritt Island is an island of mystery. The origins of its name are lost in the annals of time. At various times, it has appeared on maps with several variations of Merritt—Mauret's Island, Merritt's Island, Merit Island. Who or what the island is named for is still unknown, and local historians and residents each have their own personal favorite. The mystery involved in its name is perpetuated today by the mysteries of the Kennedy Space Complex, which is surrounded by high wire fences and armed guards patrolling the perimeter. That, too, leads to speculation and arguments, but all in all, the residents, respecting the right to privacy that was enjoyed by the earliest settlers, have learned to accommodate their lives with their neighbors to the north.

During the earliest years of settlement along the Indian River Lagoon, the Haulover Canal, a naturally occurring shallow depression that linked Indian River to Mosquito Lagoon, provided the easiest access to the region. Although only about 24 inches deep, this inlet could be used to bring in small boats and barges loaded with family possessions and trade goods in very limited quantities. The shallow depth and extreme difficulty in maneuvering on the canal did not allow for its commercial usage. It was, in many ways, the slender key that unlocked the Indian River area to only those who were highly motivated and hardy enough to brave the isolation and hardships that was the general experience of populating a wild frontier.

Families who came and stayed carved out small settlements on both shores of the lagoon, but those who claimed their homesteads on Merritt Island suffered a sense of doubled isolation. They were cut off from the mainland by the broad expanse of the lagoon and from their neighbors on the island by bogs, palmetto and oak scrubs, and mosquito-infested marshes. Yet they stayed, and many families lent their names to the small settlements that dotted the island.

"It wasn't much," one pioneer recalls, "but to us it was paradise." That single sentence accurately captures the recurring themes in conversations with and photographs of these early settlers.

ALLENHURST

A prosperous little settlement five miles south of Shiloh on Merritt Island with good fishing grounds. Settled by old established families who made a livelihood for centuries by fishing in the Mosquito Lagoon. Mrs. R. M. Teague, Postmaster.

Allenhurst Hotel L C Smith prop Allenhurst rd
Allenhurst Post Office Mrs R M Teague postmstr Allenhurst rd
Brace Linas H h Allenhurst rd

Campbell Eugenia
Crook Wallace
Eaton Frank pntr r Wm Eaton
Eaton Wm carp h Allenhurst rd
Frank Jos (Agnes) fishermn h Allenhurst rd
Frank Wm marble ctr r Jos Frank
Griffis J M
Hallum Frank
Kennard Ernest B plmbr h Allenhurst rd
Lyons Thos F (Mary A) fruit grower
Meeker R H
Murphy J C
Nauman Chas H r H R Nauman
Nauman Geo B boat bdlr r H R Nauman
Nauman Herbert R (Fanny) fishermn h Allenhurst rd
Nauman Mary F r H R Nauman
Martin Geo E farmer h Allenhurst rd
May Ernest (Nellie) fishermn h Allenhurst rd
Pattillo C T (Edna) fruit grower
Pattillo O V

Ragin R L
Ramer L (Kate) fruit grower
Smith Louis C (Fanny) prop Allenhurst Hotel h do
Smith Ruth tchr r L C Smith
Spear Leo C farmer h Allenhurst rd
Teague Chas G student r W H Teague
Teague Iona M bkpr r W H Teague
Teague Roena M Mrs postmstr h Allenhurst rd
Teague Wm H (Roena M) slsmn h Allenhurst rd
Watton Wm jr (Edna) boat bdlr h Allenhurst
Webster M F
Williams R V

Shown is a listing of Allenhurst residents from a 1926–1927 directory.

This is what is left of the store and post office at Allenhurst. The post office at the Allenhurst community was established in January 1908 and operated until September 1943.

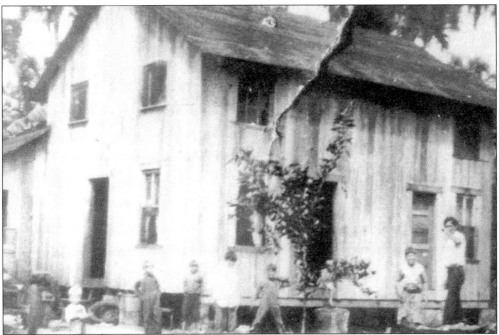

The Griffis homestead was located in the small settlement of Angel City. This house was built on North Merritt Island, across the Indian River Lagoon from Titusville. It was later dismantled and moved to Angel City. The 1930 photograph shows Bill Griffis in a spread-eagle stance in the middle.

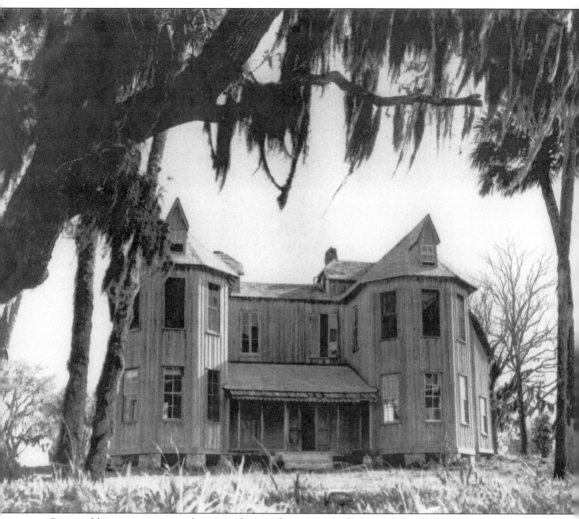

Pictured here on its original site on the northern point of Merritt Island, the Dummett "castle" was moved in 1967 to the Titusville Causeway. The structure was vandalized and later burned. The house was built by the so-called Duke and Duchess of Castellucio. She was really Jenny Anheuser, of the American beer-making family, while the bogus "Duke" was really a man named Ercole Tamajo. When the majority of Florida's citrus trees were lost in the Great Freeze of 1894–1895, the Dummett groves escaped major damage and eventually supplied most of the stock for replenishing the lost groves.

WILSON

Located nine miles east of Titusville in the center of Merritt Island, this pretty little town was named after the late President Woodrow Wilson. It is called the sportsman's paradise and is known as one of the rich fishing grounds of this part of Florida. A United States Coast Guard station is situated in the immediate vicinity of Wilson.

Churches

Wilson Community Church—Rev. Robt. Porter pastor.

Fraternal Organizations

Brevard Lodge No. 85 I. O. O. F.—W. F. Wheeler P. G. Eric Anderson N. G., Eddie Enright Sec. Meets Every Wednesday at 8 p.m. at the Community Church.

Post Office

W. F. Wheeler, postmaster.

Schools

Wilson Public School—Alma Michleau teacher.

U. S. Coast Guard

U. S. Coast Guard Station—Geo. Quarterman captain on the Beach near Wilson.

Anderson Eric (Myrtle) farmer
Atkinson Reul real est
Bailey Ralph (Lavina) farmer
Beasley Marie r Thos Hudson
Bennis Leland E
Benecke Herman (Mary) fishermn
Benecke Henry fruit grower
Bergstrom John farmer r Mrs Elise Swenson
BOSWELL RALPH C (Eliz L), Pres Boswell & Holmes Inc
Bryen Alf electn r Mrs Mary Bryen
Bryen Mary (wid Antone)
Clark H R farmer
Crawford Alvin fishermn
Crawford David farmer r Mrs Tillie Crawford
Crawford Tillie Mrs
Fields Louise r C R Randall
Fields Silas
Futch Amanda r Mrs Henry Futch
Futch Geo (Mamie) fishermn
Futch Henry Mrs
Futch Jesse fishermn
Gold Anna tchr r F R Nauman
Griffis Leonard fruit grower r Manning Griffis
Griffis Manning H farmer
Gustavus Chas
Hamilton L D fruit grower
Haselwood W H
Hesch Chas W (Mary) genl contr r Eric Anderson
Hoeck Max fruit grower

This list is of Wilson residents from a 1926–1927 directory.

Holder Danl H rd contr
Hudson Thos (Ella) lab
Kauffman Chas farmer
Martin Geo farmer
Martin Henry F (Viola)
Michleau Alma tchr Wilson Public School r Mrs Ella
 Hudson
Nauman Fred R (Rosa) fishermn
O'Flannigan T I
Parls Ira L
Parsons Steven L (Mary) carp
Peterson P Albert carp
Porter Robt Rev pastor Wilson Community Church
Post Office W F Wheeler postmaster
Quarterman Geo cartkr Canaveral Club House
Quarterman Geo Capt U S Coast Guard Sta on the
 Beach nr Wilson
Randall Chas R (Margt) carrier P O
Schnopp Anna (wid Levi)
Schnopp Anna r Mrs Anna Schnopp
Schnopp Chester farmer r Mrs Anna Schnopp
Schnopp Gladys r Mrs Anna Schnopp
Schackelford Wm farmer
Singer Benj F farmer
Spear Leo farmer
Stevens Henry P (Sarah A) farmer
Swenson Elise Mrs
Tinney Mabel r Henry Benecke
U S Coast Guard Station Geo Quarterman Capt on the
 Beach nr Wilson
Virgin Roscoe S farmer
Weider J P r C W Hesch
Wheeler Myra G Mrs (Wilson Fill Sta) fill sta and
 confr
Wheeler Wm F (Myra G) postmaster
Wilson Community Church Rev Robt Porter pastor
Wilson Filling Station Mrs M G Wheeler prop
Wilson LaVerne farmer
Wilson Public School Alma Michleau tchr
Worthington H G farmer

This is the directory listing continued.

Capt. Mills Olcott Burnham was the first permanent keeper assigned to the Cape Canaveral lighthouse. He was the keeper of the light from 1853 to 1868. During the War between the States, he had the light dismantled and buried to keep it from enemy hands. Burnham and his wife, Mary, had seven children. Their five daughters married into the Wilson, Quarterman, Knight, and Nauman families. Here, son-in-law George Quarterman, who married Anna Dummett Burnham, proudly poses in his grove at Wilson on North Merritt Island.

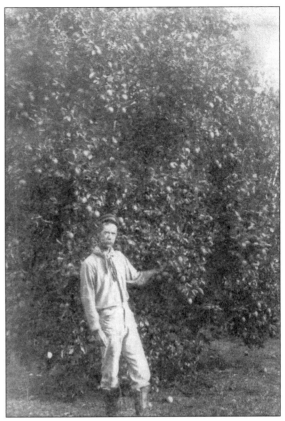

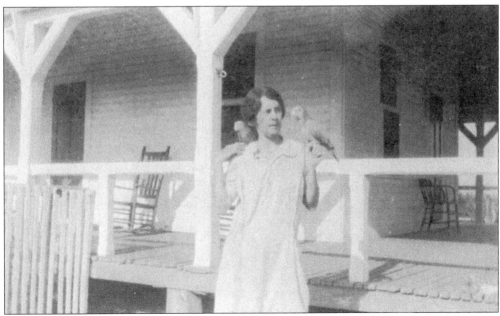

Anna Stewart Quarterman is seen with parrots at the Chester Shoal Coast Guard House of Refuge. Part of a string of coastal safe houses for shipwrecked sailors designed by Francis W. Chandler, the houses were built during the period from 1875 to 1885. (U.S. Coast Guard.)

The Chester Shoal House of Refuge, located near the now defunct Canaveral Club, was part of a chain of house and life-saving stations built along the eastern coast of Florida. They were identical in design. Only the Jupiter Inlet House of Refuge exists today. It is operated as a museum.

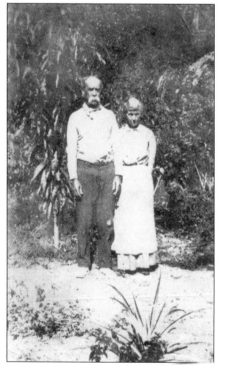

Pictured are George Quarterman and his wife, Anna Dummett Burnham Quarterman. Following the death of Capt. Mills O. Burnham, his son-in-law, George Quarterman, assumed responsibility for maintaining the Cape Canaveral lighthouse. Floyd Quarterman, the son of George and Anna, was the last lighthouse keeper.

Two

BANANA CREEK SOUTH:

BANANA CREEK TO HIGHWAY 520, ORSINO, COURTENAY, AND INDIANOLA

Each small community on Merritt Island had its own social and commercial dynamic. The Field family, who operated citrus groves and the community general store, dominated Indianola. Orsino had the Howes, a family with aspirations of making their community a modern city with all the latest conveniences—electricity, telephones, and telegraphs. Courtenay, another citrus-growing community, was a focal point of the citrus and fishing industries. Up and down the Indian River, along the shores of Sykes Creek, and out into the Banana River, dilapidated docks, lonely pilings of half-rotten wood, and overgrown landings give mute testimony to the bustling energy and large ambitions of the earlier residents.

Of course, nothing stays the same. While the early settlers of this area were busy creating an enjoyable life in this out-of-the-way paradise, they were also sowing the seeds for the later destruction of the very lifestyle they cherished. The success they enjoyed allowed them to improve gradually their lot in life and to ensure that their descendants would enjoy an even more prosperous existence. The availability of large tracts of open farmland and stands of coastal timber, coupled with mild climate and sparse population, proved a tantalizing lure for promoters and developers, who touted the desirability of the region in national and international newspapers and magazines. The whole of Merritt Island was projected as part of the grandiose development of the East Coast from Key West to Jacksonville.

The same qualities that encouraged the speculators and investors, however, also attracted the attention of government planners. When the search began to find a place to locate the nation's rocket program, northern Merritt Island and Cape Canaveral—choice development sites for vacation homes and resorts—were recognized as being ideal for the solitary and secretive business of military rockets and space travel.

Many of the small villages that once flourished on Merritt Island were obliterated in the 1950s when the federal government, using its vast monetary resources and the power of *eminent domain,* bought or confiscated these communities for inclusion in the space and rocketry complex on the island's northern end. Despite their physical disappearance, these now-gone communities still exist in the memories of those who lived there and on maps as street and place names. To hear conversations between descendants of these early residents is to take a trip into the past as their recollections create vivid pictures of lost places and deceased personalities. In this way, these pioneering settlers live on, fondly remembered and achingly missed.

ORSINO

Midway on Merritt Island, about 15 miles north of Merritt City. Orsino is the terminal of a new state road going north through the island. Chas. V. Roberts postmaster.

Orsino Community Church—Rev. C. B. Poland, pastor.

Orsino Public School—J. E. Bridgewater, teacher.

Atkinson Geo (Ruth) farmer
Avery Orlie J (Pearl) lab
Bagwell Benj H lab
Bath Fred
Bridgewater Jos E (Cath) tchr Orsino Public School
Callerman A L
Campbell Marshall (Zoe) farmer
Carboni G C (Alfredda)
Cloud Robt P (Anna) switchmn F E C Ry
Collins Paul D (Adaline) mech
David Chas (Ethel) lab
Dewey Lynn lab
Dombrok Henry farmer
Elliott Jas r W H Elliott
Elliott Kath r W H Elliott
Elliott Wm H
Fox Wm H (Helen) fruit grower
Furnari Filippo (Palme) farmer
Garofolo Angelo (Minnie) farmer
Garofolo Josephine r Angelo Garofolo
Gough Timothy mech
Guedrey B W (Anna) farmer
Howe Carl r W H Howe
Howe Walter H (Sara E)
Hoxie Florin B (Grace) farmer
Jacobson Hans
Jones Eli F (Callie) carp
McKain Jos H (McKain & Beensen, Cocoa)
Malone Arth r David Malone
Malone David
Malone Harry (Leona) slsmn
Malone Victor (Della) eng
Mellon J H
Moran Chas farmer
Olson Andrew
Orsino Community Church C B Poland pastor
Orsino Public School J E Bridgewater tchr
Poland Benj F (Lottie) clk
Poland Cyrus B (Emily) farmer
Post Office C V Roberts postmstr
Quinn Willis
Roberts Chas V (Laurel) postmstr
Roberts Jennie (wid Frank)
Roberts Roy F (Edna) farmer and genl mdse
RUDESILL DICK (Nellie; A A Buck & Co, Cocoa)
Sharit A L
Sharit M S
Smith Orsino T farmer
Stevens Chas F (Cordelia) mech Indian River Garage Inc
Taylor E Wright lawyer

Shown is a listing of Orsino residents from a 1926–1927 directory.

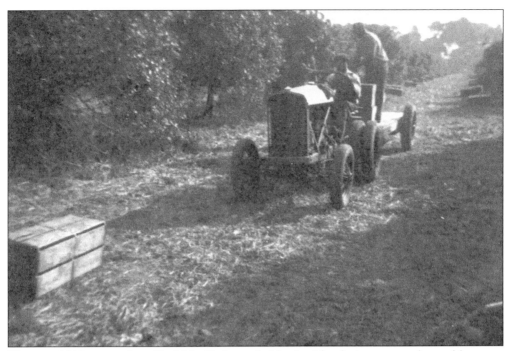

This is a 1940s scene from Paul Mueller's north Merritt Island citrus grove, located between Orsino and Courtenay. Note the homemade tractor—an automobile converted to a tractor.

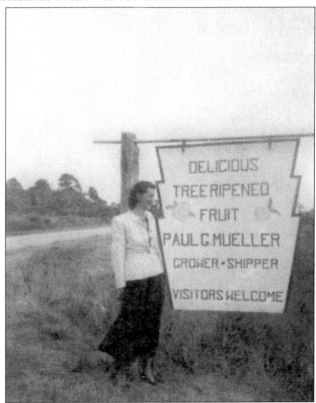

In this 1950s photograph, Clara Lewis Mueller (Mrs. Paul Mueller) admires the sign advertising the harvest of the family's grove near Orsino. The Muellers came to Florida from New Jersey. Paul Mueller became very active in the Brevard County Farm Bureau.

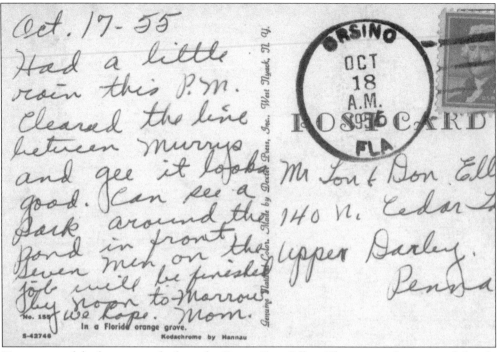

Oct. 17 - 55
Had a little
rain this P.M.
Cleared the line
between murrys
and gee it looks
good. Can see a
park around the
pond in front.
Seven men on the
job will be finished
by noon to-marrow.
We hope. Mom.

No. 155
In a Florida orange grove.
S-42746
Kodachrome by Hannau

Genuine Natural Color. Made by Dexter Press, Inc., West Nyack, N. Y.

POST CARD

Mr Jou & Don Ell
140 N. Cedar S
Upper Darby.
Penna

ORSINO
OCT
18
A.M.
1955
FLA

Here is one of the last postmarks from the Orsino Post Office. This postmark was issued shortly before the land around the community was confiscated by the federal government for the soon-to-be-built Kennedy Space Center.

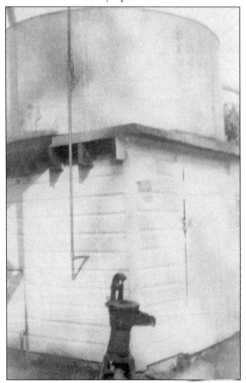

The Paul Mueller family depended upon this elevated rain barrel and pump for drinking water in the early 1940s.

Shown is the assignment page of *Work and Play with Numbers*, published by Geo. Wentworth and David E. Smith in 1912. It was still in use by students at the Orsino School in 1926.

The rear cover of *Work and Play with Numbers* featured a price notice to prevent booksellers from overcharging in an era when students had to buy their own books.

Paul Mueller's north Merritt Island grove in the 1940s is shown here. Clearing virgin land to plant young citrus seedlings was a daunting task without modern machinery.

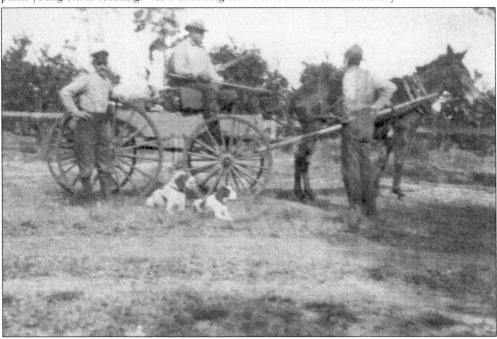

Early Merritt Island residents had a long way to go (or row) to find a grocery store. Trade boats brought staples to the island, but meals with fresh vegetables and meat depended on the gardening and hunting skills of the island's inhabitants. Here, a hunting party, complete with eager dogs, prepares for a hunt.

COURTENAY

Located 8 miles north of Merritt City on Merrit
Island, on the new County Highway. Beautiful citru
groves are in abundance in this part of the Island
Post Office—Mrs. Alice Godbey postmaster.
St. Luke's Episcopal Church—Rev. C. D. Bascom pas
 tor.
St. Luke's Cemetery.
Courtenay School—Edna Daniel teacher.
Adams R F
Bascom C D Rev pastor St Luke's Episcopal Churc
Beensen Chas (Julia B; McKain & Beensen)
*Burt Wm lab r S Edwards
Chrisafulli Chas (Mary) farmer
Chrisafulli Jos (Madeline) fruit grower
Courtenay Public School Edna Daniel tchr
Courtenay Store (D D Green) genl mdse and fill st
Daniel Edna tchr Courtenay Public School r H I
 Sams
Dewey Lyman M
Dingman R V (Celestina) pntr
Durden C R lab
*Edwards Sylvester (Mary) lab
*Fuller Agnes
Fuller Wm A
Godbey Alice Mrs postmaster
Godbey Lois E student r Robt Godbey
Godbey Robt (Alice) clk Cocoa P O
Godbey Victor C student r Robt Godbey
Green Dallas D (Evie; Courtenay Store)
Gurney Walter farmer
Jenkins Harry (Kath) fruit grower
Jenkins Jas L lab r Harry Jenkins
Jenkins Kath student r Harry Jenkins
LaRoche Benj B (Martha) fruit grower
LaRoche Bonham blksmith r B B LaRoche
LaRoche Daniel J (Judie) fruit grower
LaRoche Edw W (Mary) fruit grower
LaRoche Eliz H (wid Frank)
LaRoche Frank student r Judson LaRoche
LaRoche Frank L fruit grower r D J LaRoche
LaRoche Herbert (Christine) fruit grower r R J La
 Roche
LaRoche John J (Marian) fruit grower
LaRoche Judson (Mildred) fruit grower
LaRoche Marian student r J J LaRoche
LaRoche R B
LaRoche Richd J (Martha) fruit grower
LaRoche Robt jr student r R B LaRoche
LaRoche Robt B (Eliz) fruit grower
LaRoche Wm F (Eva) fruit grower r Mrs Eliz La-
 Roche
Livingston Bert
McGill Vida I (wid R G) r D C Williams
*Mathis Arth r Richd Wright
Mayfield Maurine r S L Wottring

Shown here is a listing of Courtenay residents from a 1926–1927 directory.

Melton Aug tractor driver r W M Melton
Melton Hugh truck driver r W M Melton
Melton Wm jr r W M Melton
Melton Wm M (Nancy) mgr E P Porcher
Michaelson S C fruit grower
Morton Allett G fruit grower
Morton Ernest r A G Morton
Morton Theo lab r Walter Morton
Morton Walter (Sarah) lab
*Phillips Jas (Mattie) lab
*Phillips John r Jas Phillips
*Phillips Rose r Jas Phillips
Post Office Mrs Alice Godbey postmaster
Quinten Eliza
Quinten Thos G farmer
Rummell Richd W (Grace) archt
St Luke's Cemetery
St Luke's Episcopal Church Rev C D Bascom pastor
Sams Brady lab r DeVeaux Sams
Sams Cestina r H H Sams

Sams Devoe (Jennie) mail carrier
Sams Horace H fruit grower
Sams Wm S (Anna C) carp
Seawright Jos A
Sellers J J
Taylor Olen W fruit grower
Toler C J
*Turnbull Saml fruit grower
Whaley M S (Amantha) fruit grower
Wheeler Jas jr r J R Wheeler
Wheeler Jas R (Martha) fruit grower
Wheeler Wm r J R Wheeler
*White Cleveland (Charlotte) lab
Williams Agnes student r D C Williams
Williams Ara B nurse r D C Williams
Williams David C (Sallie)
Williams Leslie D fruit grower r D C Williams
Williams Sarah C student r D C Williams
Worth David G

The directory listing is continued.

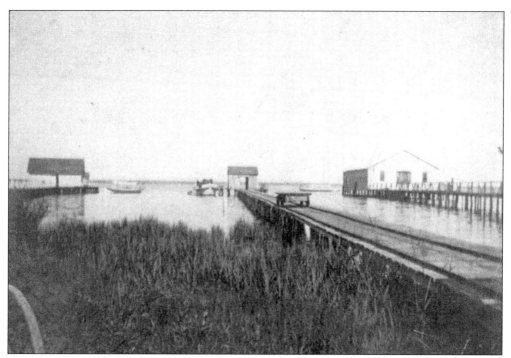

Built long enough to reach deep water where large paddlewheel boats could tie up, these Courtenay docks were typical of hundreds of similar docks along the Indian River Lagoon. Early settlers on Merritt Island depended on steamboats to ferry cargo to and from the island. Note the rails on the dock and the cart that were used to shuttle cargo from the boats to the land.

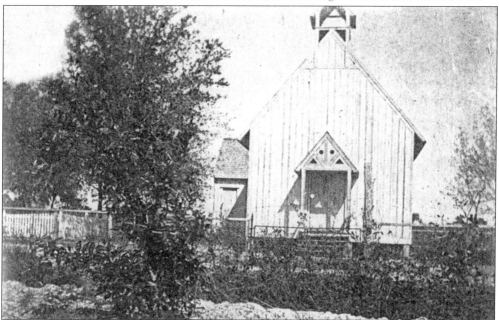

This unusual dated photograph shows the Episcopal Church at Courtenay in 1898. The church, which was established in the 1880s, still survives and is surrounded by a picturesque cemetery where the graves of many early pioneers can be found.

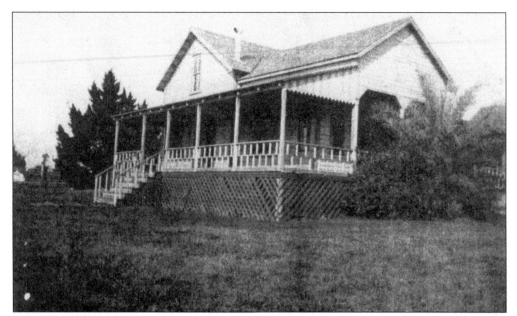

This is a view of the E.P. Porcher house at Courtenay. While Edward Postell Porcher operated a packinghouse in Cocoa, he also had vast citrus holdings on north Merritt Island. He floated his fruit to the mainland on barges. Later, when the wooden bridge to the island was in place, the fruit was trucked to the packinghouse on vehicles with large solid rubber tires. The Cocoa home of E.P. Porcher was built of coquina rock.

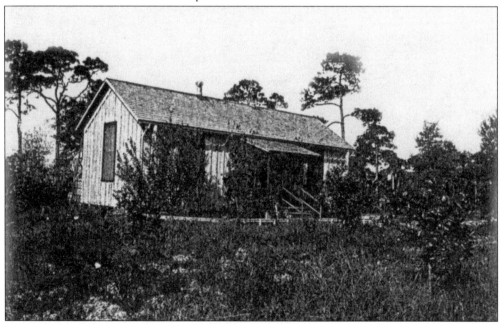

Around 1900, Sarah Julia Porcher, a sister of Edward P. Porcher, lived in this modest home located near Courtenay. "Aunt Julia" never married, but reared her nephew, Lawrence Porcher Allen, the son of her sister Laura. A music teacher at a women's college in Roanoke, Virginia, before she came to Merritt Island, her first love was photography. She developed the film she shot. Aunt Julia was a very unusual lady for her time.

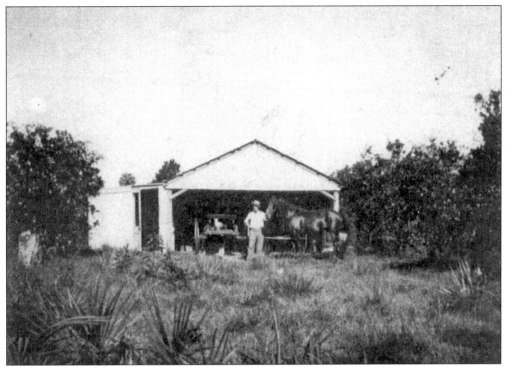

These are E.P. Porcher's stables at Courtenay on north Merritt Island around 1910. Porcher used mules and horses to work the citrus groves. Fruit picked here was taken by wagon to steamboats on the Indian River Lagoon and eventually made its way north to Jacksonville.

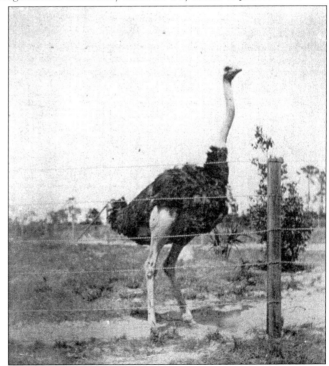

This turn-of-the-20th-century ostrich farm belonged to W.J. Griffin, a resident of Courtenay.

This is a rare photograph of the interior of the Courtenay Post Office.

(0632.)	Post Office and State. Courtenay Fla	Date, Dec 5 , 1903	
RECEIVED OF M M Allen , late postmaster at Courtenay			
the following-described postage-stamped paper:			

QUANTITY.	DENOMINATION.	DESCRIPTION.	VALUE.
265	1-cent........	Ordinary stamps...........	2 65
632	2-cent........	" "	12 64
29	3-cent........	" "	87
63	4-cent........	" "	2 52
28	5-cent........	" "	1 80
X	6-cent........	" "	
47	8-cent........	" "	3 76
3	10-cent.......	" "	30
X	10-cent, S. D..	Special-delivery stamps....	
14	24-cent (12)...	Books of 12 ordinary stamps...........	4 40
	48-cent (24)...	" 24 " "	
	97-cent (48)...	" 48 " "	
	1-cent........	Postage-due stamps............	
	2-cent........	" "	
450	1-cent........	Postal cards...........	4 50
	2-cent........	" "	
2	25	Stamped envelopes...........	53
5	625	" "	13 23
10	42	" "	1 04
11	163	" "	3 57
8	248	" "	5 57
		" "	
		" "	
2 2	1-cent........	Newspaper wrappers...........	2 44
425	1¢.	" "	4 67
		TOTAL (This total must agree with the sum on the "Original")......	68 34

DUPLICATE. (For late postmaster.)	Witness:	Richard J La Roche
	C P Allen	Postmaster.

Richard J. LaRoche was the postmaster of Courtenay in 1903 when this inventory of the post office was made. Mr. LaRoche replaced M.M. Allen as postmaster and an inventory was necessary. Lawrence Porcher Allen witnessed the inventory and the transfer of postal department property.

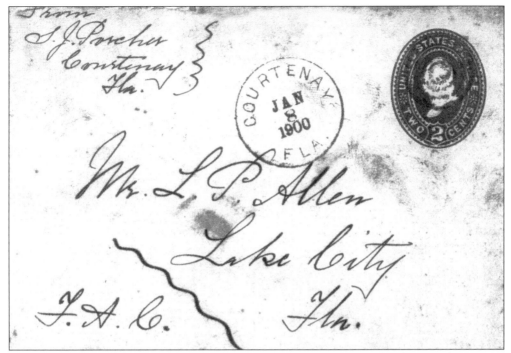

This postmark from the Courtenay Post Office is dated January 8, 1900. The initials "F.A.C." refer to the Florida Agricultural College, which was located in Lake City, Florida. It later became part of the University of Florida at Gainesville.

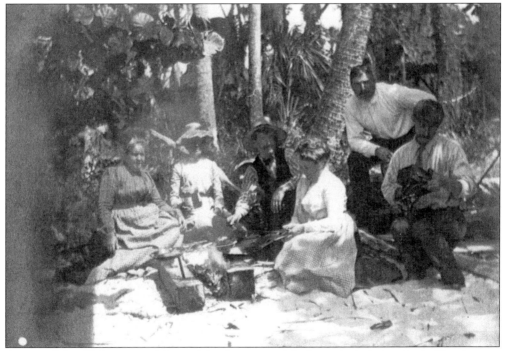

A turn-of-the-20th-century Merritt Island outing might have included a picnic like the one pictured here.

This early one-room schoolhouse was located at Courtenay in 1895. Pupils walked as much as 5 miles one way to attend school.

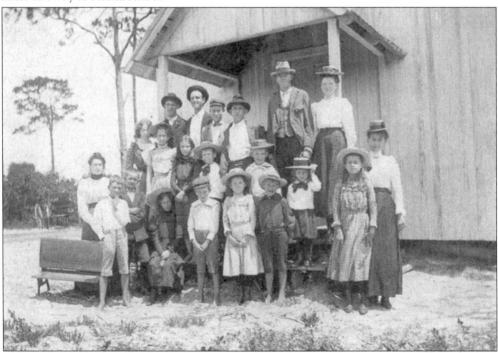

Miss Margaret McElroy presided at this one-room schoolhouse in Courtenay around 1895. The eager pupils pictured here are, from left to right, Madge Whitlock, W. LaRoche, Amarintha Jenkins, Jimmy Jenkins, Francis LaRoche, James LaRoche, Clement LaRoche, Ernest Sams, Franklin Sams, Tommy Sams, Charlie Sams, Fannie Sams, Judson LaRoche, Littleton LaRoche, Richard LaRoche, Stella Harper, Myrtle Harper, Loula Harper, and Bessie Harper.

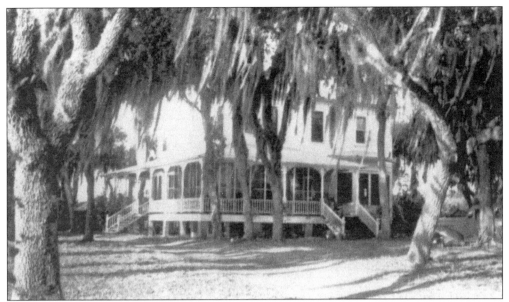

The home of R.J. LaRoche was located off Tropical Trail north of Courtenay. Early homes faced the Indian River because this was the mode of transportation. The home has been restored to its original condition and is occupied today.

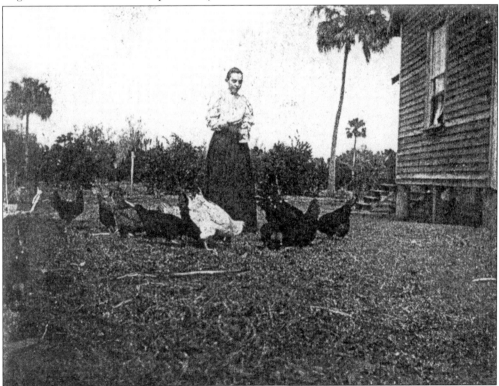

Mrs. F.W. LaRoche is pictured feeding chickens at Courtenay in 1898. Almost every household had chickens to provide eggs and fresh meat. The chickens were fed late every afternoon before they went to roost.

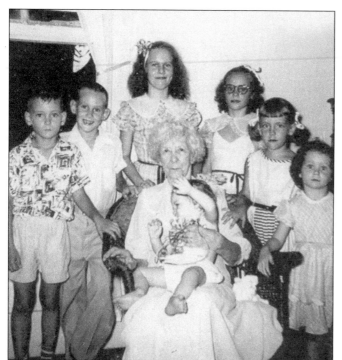

Emily Whitlock LaRoche, the widow of Daniel LaRoche, celebrated her 90th birthday in 1954 with some of her grandchildren. Pictured, from left to right, are Rodney Bournefield, Michael Brannin, Sandra Brannin, Michelle Brannin, Beverly LaRoche, and Patrica Bournefield. Mrs. LaRoche, fondly referred to as "DaDa," is holding Adele LaRoche.

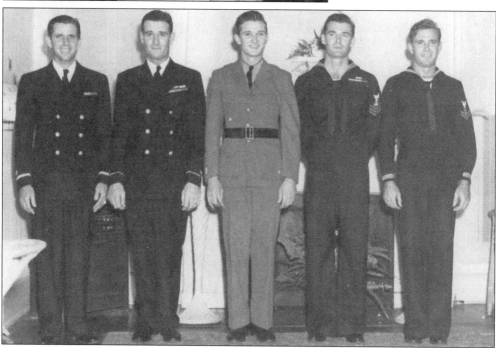

The five Butler boys of Courtenay are pictured here on August 23, 1944, in uniform. They are, from left to right, Victor, Loran, Wilbur, Lester, and Felton Butler. The sons of Alburn Street "Doc" Butler and Emma Lee Butler, they were all in the Navy at the time, with the exception of Wilbur, who was in military school. The occasion was the wedding of Anne Gettings to Lorah Butler.

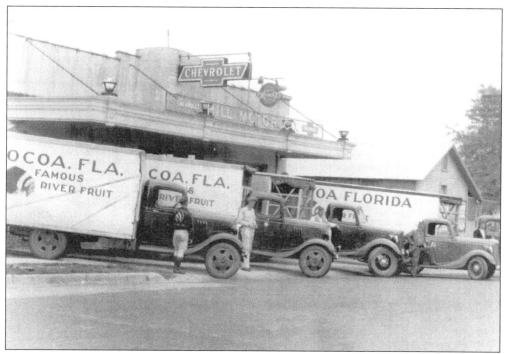

In the mid-1930s, L.P. Allen became dissatisfied with the methods used by Railroad Express to ship fruit to Jacksonville and points north. He purchased his own fleet of trucks to deliver fruit. Pictured are two Chevrolets and two Fords. The smaller Ford is Mr. Allen's personal pickup.

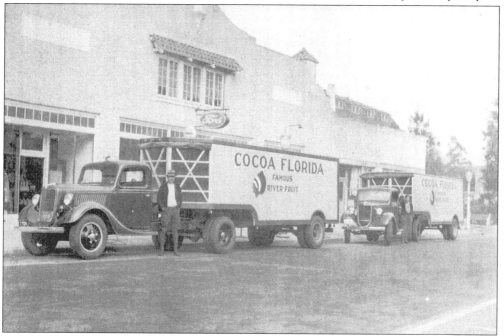

Pictured here is Brevard Avenue in January 1936. Indications are that Mr. Allen purchased two Fords and two Chevrolets to keep both dealers happy. Drivers Van Alstyne and Burnett are shown.

The wharf at Courtenay is shown here. In certain locations, piers needed to be long enough to reach deeper waters. The steamers claimed to be able to run on a heavy dew but, in reality, needed water a minimum of 3 feet deep.

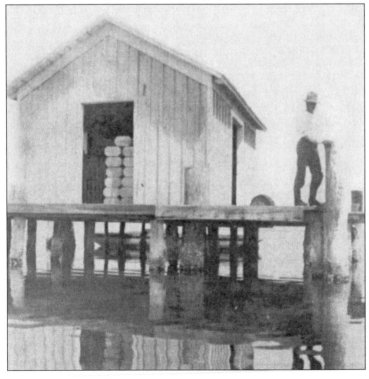

Julia Porcher photographed her nephew, Lawrence Porcher Allen, as he waited for the launch of his uncle, E.P. Porcher, to arrive.

This photograph was taken in the riverfront grove of E.P. Porcher in February 1898 by Mrs. D.A. Blodgett. E.P. Porcher and his wife, Byrnina Peck Porcher, are shown here. Many of the area's groves disappeared with the growth of the missile ranges and space center.

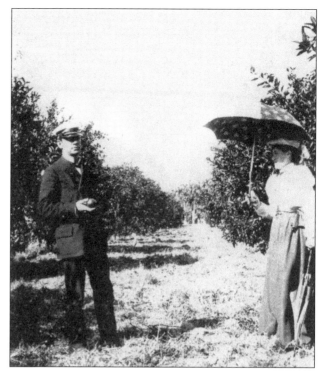

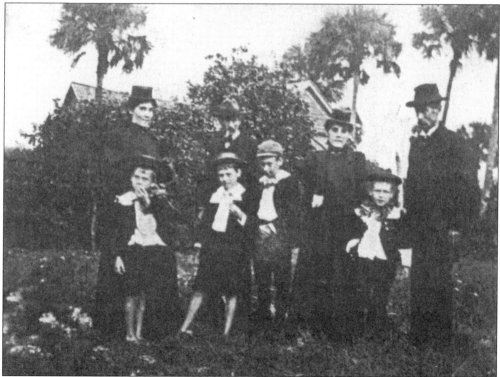

The R.J. and R.B. LaRoche families had their picture taken at Courtenay. According to the legend on the picture, this photograph was made at 12:30 p.m. on January 8, 1899.

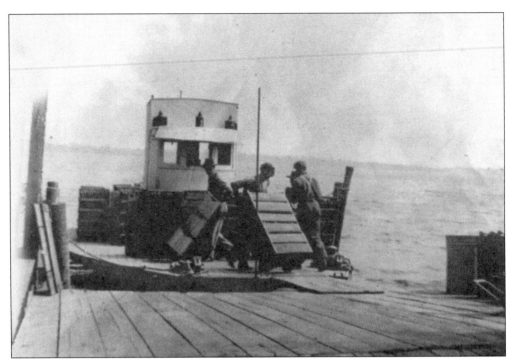

Field crates of citrus are in the process of being moved by barge from the Courtenay groves to the Porcher packinghouse, located across the river just north of the Porcher home in Cocoa.

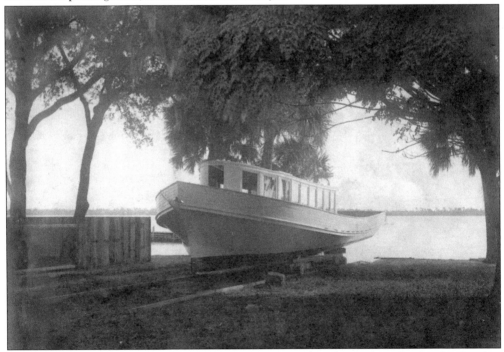

This 1906 photograph shows the *Falcon*, the E.P. Porcher family launch. As the Porcher family's fortunes prospered, their private launch was replaced by larger boats. This is the third *Falcon*.

INDIANOLA

Adjoins Merritt City on the north. Beautiful homes line the banks of the Indian River amid rich orange groves. Rural free delivery from Cocoa.

Indianola Baptist Church.

Indianola Cemetery.

Indianola Social Club—J. E. Fields pres, C. L. Hill v-pres, F. G. Humphrys sec-treas.

Allen Dairy (T O John)
Andrix Curtis P fruit grower
Barr Wm (Willis-Barr Awning Co) r J H Willis
Bell Wm S r W F Smithie
*Bishop Geo (Oveda) lab
Blythe Mary N Mrs
Blythe Thos P (Winifred) formn Roscoe McLean
Britt Demmock (Minnie) lab r J W Britt
Britt John W (Virginia) fruit grower
Britt Jos H carp r J W Britt

Britt Young lab r J W Britt
BUCK ARTHUR A (Martha E; A A Buck & Co, Cocoa), Phone 3002
*Cooper Benj C (Mary) lab
Crowell Thos R (Forrest) grove mgr
*Davenport Jos (Lucille) lab
Dixon Ethel (wid Ernest) sten r G L McIntosh
Dixon Henry carp r G L McIntosh
Dixon Leland carp r G L McIntosh
Donnelly Thos
Dyal Enoch R (Susan) fruit grower
Estes Harold C (Hulda; Bywatyr Coffee Shop) r W D Gotshall
Estes Roy M r W D Gotshall
Field Eliza A (wid John R)
FIELD JOS E (Louise H; Logan & Field, Cocoa), r Mrs Eliza A Field
Gaddis Chas lab r C H Johnson
*Goss John C (Lillie) lab r Geo Bishop
Gotshall Jas E (Janet M)

Gotshall Janet student r J E Gotshall
Gotshall Sallie r W D Gotshall
Gotshall Wm D
Grandjean John A (Marie) fruit grower
Grant Carene B r R S S Grant
Grant P Simpson student r R S S Grant
Grant Robt S S fruit grower
Hildreth Edw (Nora) fruit grower
Hill Chas L fruit grower
Hill Robt S fruit grower r C L Hill
Humphrys Alfred S (Martha H)
Humphrys F G
Hylton Thos P
Indianola Baptist Church
Indianola Cemetery
Indianola Social Club J E Fields pres, C L Hill v-pres, F G Humphrys sec-treas
John Thos O (Ela; Allen Dairy)
Johnson Clarence H (Ethel) pipefitter

Listed are Indianola residents from a 1926–1927 directory.

37

*Johnson Martin (Emma) lab
*Lane Isaac (Susan) lab
Lapham Jelly Co Inc office Cocoa Fla
Little Geo H
Lockett David T (Maude) fruit grower
Lockett Norwood r D T Lockett
McIntosh Geo L (Mrytle) carp
Matteson Grace M r O B Matteson
Matteson Otis B
Miott John R r Mrs Eliza A Field
Nesbitt Mabel (wid D St E)
Nickerson Chas (Florence) carp
Northrup Chas C
Owens Jos (Lillian) plmbr
Owens Thos A plmbr r Jos Owens
Pattin Wm (Olive)
Peterson Ralph lab r Wm Peterson
Peterson Wm (Floridan) lab
Pettit Clark R real est
Pinner Ezekiel (Mattie) lab
Pinner Floyd lab r Ezekiel Pinner
Reed John E (Ethel A; Provost Reed & Fiske Coc
Reed Mary I r J E Reed
Richards Carrie H (wid C E) r M S Humphrys
Sanders Eugenia (wid T S)
Sargent Chas W (Bertha B) acct
*Sims Butler lab r Moses Sims
*Sims Moses (Octavia) lab
Smithie Wm F (Mary) fruit grower
Stackhouse Harry A (Sarah C) fruit grower
Stackhouse Nathan C student r H F Stackhouse
Turnbull Agnes maid r C L Hill
Whittaker Frank fruit grower
Whittington Roger (Myrtice) carp
*Williams Geo lab r Jos Williams
*Williams Jos (Marie) lab
Willis John H (Anna E)
Willis John H jr mgr Virginia Park r J H Willis
Wooten Cornelia (wid A J) r Eugenia Sanders

Here is the directory listing continued.

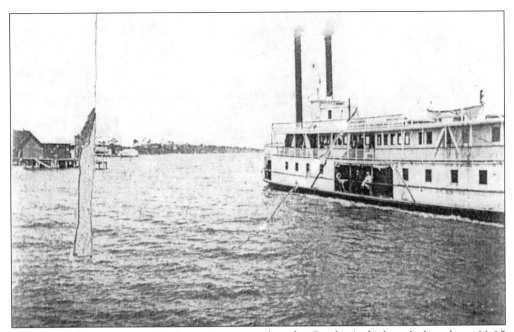

The Indian River steamer *St. Augustine* approaches the Sanders's dock at Indianola at 11:15 a.m. on April 21, 1898. One Indian River captain described the *St. Augustine* as the prettiest and fastest boat on the lagoon. Capt. Alex Goode of Melbourne was most often in command of this boat.

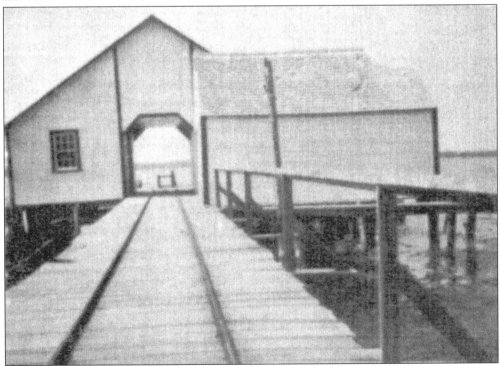

Here is the dock at Indianola, a stopping place for steamers plying the Indian River. The rails allowed heavy loads to be pushed out on a tramcar to the end of the dock for deeper water.

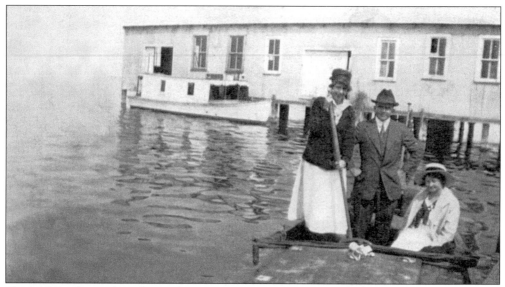

The Mill Dock at Indianola was the stopping point for the steamboats serving Indianola on the Indian River at the turn of the 20th century.

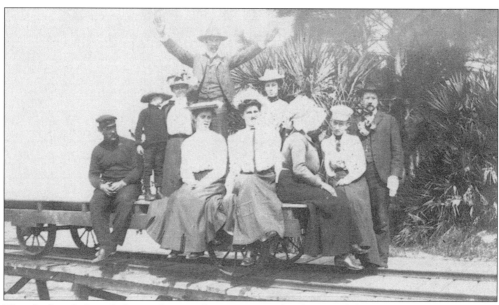

This dock at Indianola boasted a cart that ran on steel rails to push loads to and from the shore to the end of the dock to meet the boats. The Indian River was so shallow in places that docks were built anywhere from 300 feet to 1,000 feet long to reach water deep enough for steamboats to operate. This time the cart was for passengers.

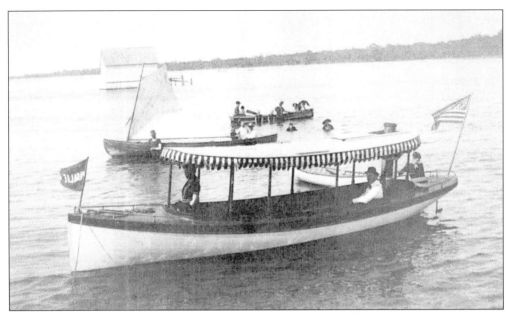

The *Bob–O Link* was one of the first motor boats on the Indian River. It was built by famous racing boat builder George Gingras, and owned by Dr. Charles L. Hill. This picture is from about 1902.

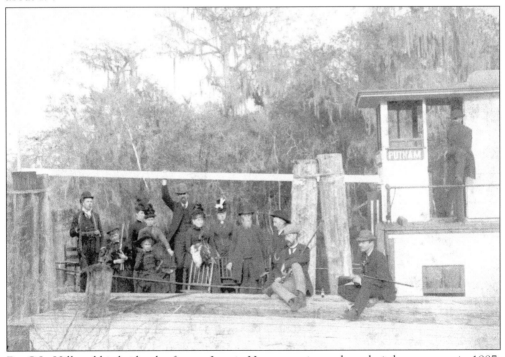

Dr. C.L. Hill and his bride, the former Jennie Hoos, are pictured on their honeymoon in 1887. Neither had visited Florida before and were told in Palatka that the railroad was headed south. They, being young (both 21 years of age at the time) and adventuresome, decided to follow the advice to go south. They settled in Indianola at "Hill Holme." The newlyweds are pictured on the far left.

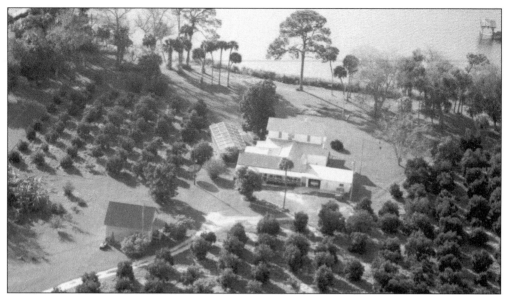

The John R. Field Homestead and the present home of Clyde Field is located at Indianola. The homestead paper was signed by Chester A. Arthur in 1882. The structure was placed on the National Register in 1997.

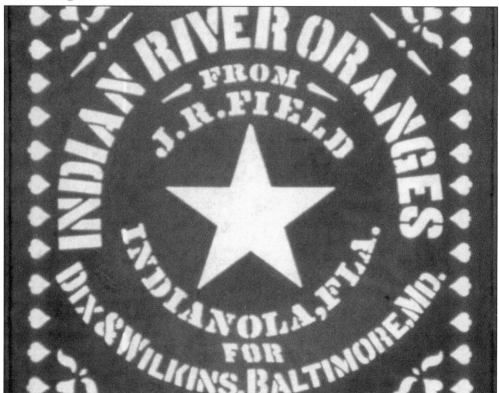

Pictured here is a brass stencil used to label the ends of citrus boxes. The grove owner and shipper was John R. Field of Indianola. The stencil and the grove still belong to the Field family.

This brass stencil was used by John R. Miot, a fruit grower and cattleman. Bold lettering advertises the virtues of now famous Indian River Fruit.

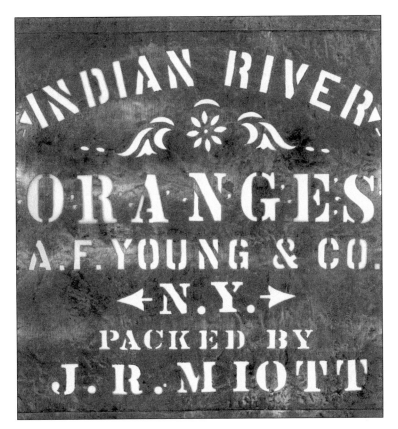

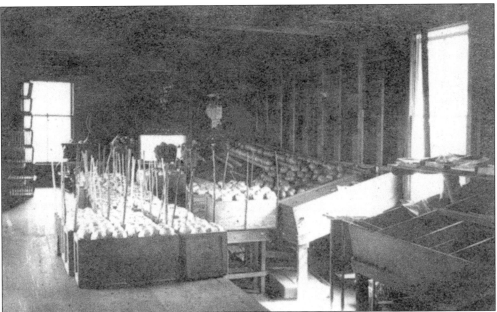

Citrus packinghouses were busy places. Each piece of fruit was wrapped separately. The wooden strips were bent over the top of the boxes and nailed to secure the top. Metal bands were later used to secure the box tops.

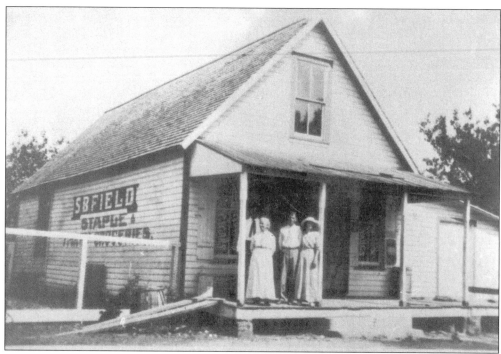

The Field's Store and Indianola Post Office were located in this building. The post office was established on January 22, 1889, and closed on May 15, 1925. Mail was then delivered by the Cocoa Post Office.

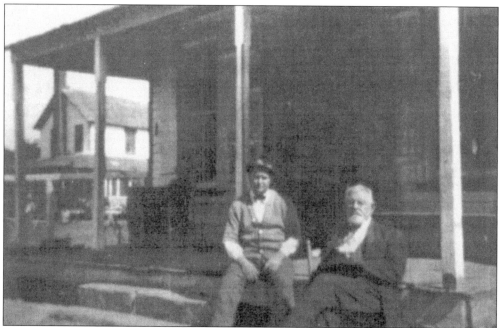

The post office and general store at Indianola was a community gathering place. Seated in front of the building is Sam Field, the first postmaster and proprietor of the store.

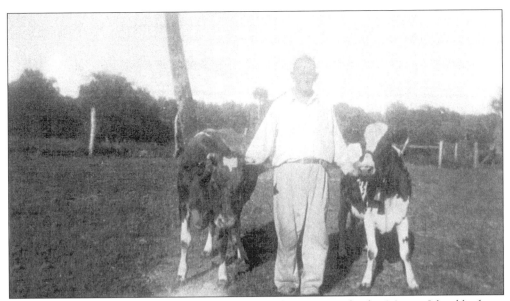

Joe Field is pictured here with a milch cow and an almost grown heifer. Merritt Island had two dairies—Curtis' Dairy at Audubon and John's Dairy at Indianola, but many families had their own cow for milk and butter.

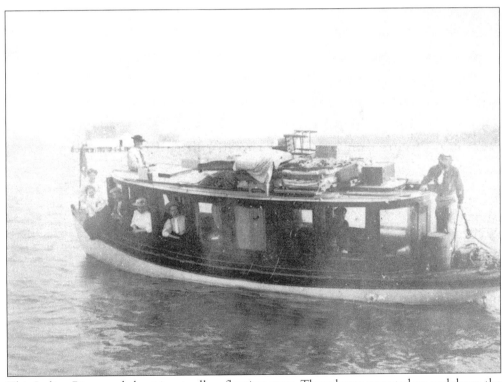

This Indian River trade boat is actually a floating store. These boats operated up and down the river, buying, selling, and trading wares.

A Scotsman by birth, David St. Clair Nisbet came, along with countrymen James Finley Mitchell and Robert Simson Stevenson Grant, to homestead on Merritt Island about 1885. The group was advised before they left Scotland, by someone already here, to bring with them all the tools they could lay their hands on and plenty of warm clothes!

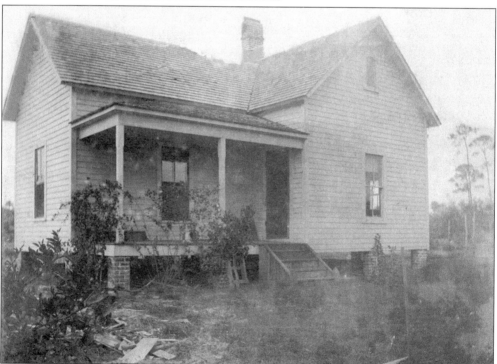

Nisbet chose his homestead near the present-day location of the causeway at Indianola. First, he built a palmetto-roofed shack and then this house, which is still standing at this time.

David Simson Nisbet, son of David St. Clair Nisbet, grew up on Merritt Island and helped shape the Brevard County of today. In addition to his business as Standard Oil distributor, he was a Brevard County commissioner from District 2 from 1950 through 1958. He was a Port Canaveral authority commissioner on the very first board. Being a citrus grower, bank director, a military-civilian relations advisor, and a family man occupied his spare time. He liked to refer to Gen. Douglas MacArthur's words "Youth is not entirely a time of life–it is a state of mind."

David Curtis Williams brought his family to Courtenay in 1922. He promptly sent his son Leslie to the university to learn citrus culture. One of his daughters, Sarah Curtis Williams, became the bride of David Simson Nisbet.

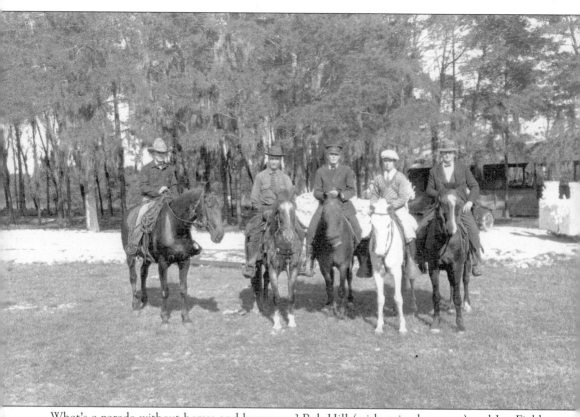

What's a parade without horses and horsemen? Bob Hill (with striped sweater) and Joe Field, both of Indianola, participated in this one. Note the float and old cars in the background.

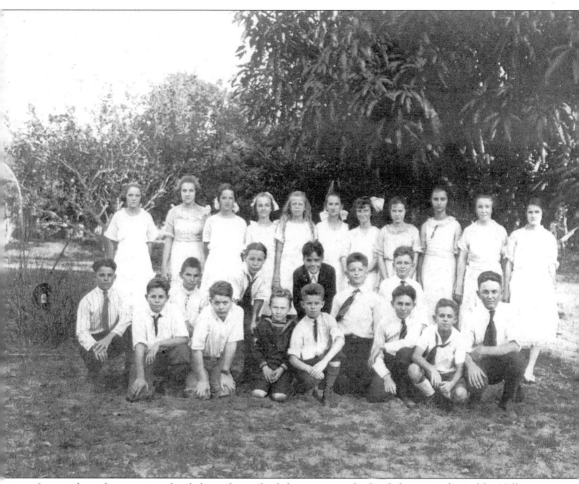

It must have been a giant birthday cake to feed the guests at the birthday party for Bobby Hill at his home in Indianola. Note the huge mango tree behind the group in this 1920 photo. The girls, from left to right, are Mildred Strickland, Alpha Daniel, Lucy Lucas, Mary Jane Holderman, Emily Allen, Evelyn Drysdale, Anena Daniel, Dorothy Packard, Florence Smith, Mary Margaret McKeown, and Mary Reed. The boys, from left to right, are Edward Baggett, Simson Grant, Harold Smith, Billy Pankey, Arthur McKeown, David Nisbet (in sailor suit), Robert Hill, Frank Hayes, Hugh Gingras, Stanford Martin, John Fiske, Bobby Schlernitzauer, and Milton Strickland.

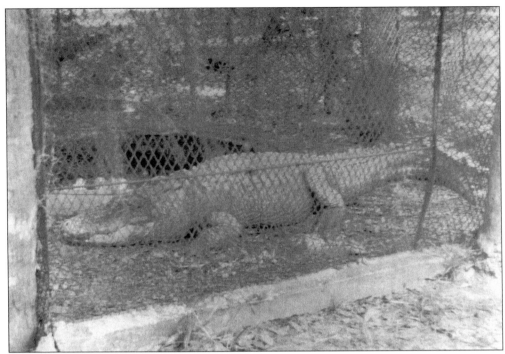

A Merritt Island celebrity was this giant alligator who resided in a pen at "Hill Holme" at Indianola. A favorite Sunday afternoon diversion was to row to the island from the mainland to see the "gator," reportedly called "Jumbo" or "The General"—depending on to whom you talked.

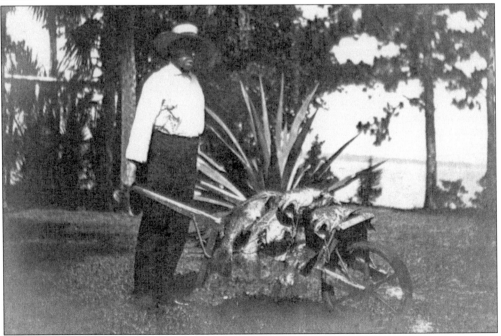

It is lunchtime for the alligator. Dr. Hill has a wheelbarrow load of fish for his guest. Dr. Hill also had alligators other than Jumbo, the big gator.

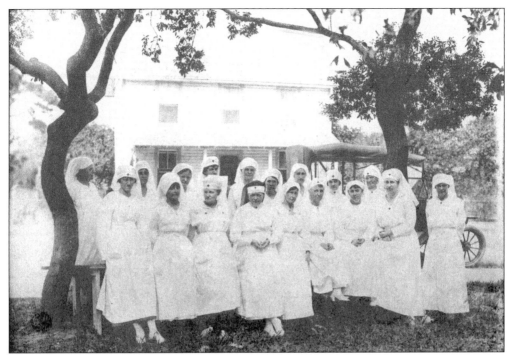

This group of patriotic ladies were members of the Red Cross in Central Brevard County. Here they are meeting on Merritt Island to aid the World War I effort. They are, from left to right, as follows: (front row) Katinka Myers, Mattie Buck, unidentified, Jennie Hill, Mrs. Meyers, Mrs. Patterson, Mrs. Fuegner, unidentified, and Ethel Reed; (back row) three unidentified women, Mrs. Fred Travis, Mrs. Hindle, Mrs. Grosse, Mrs. Lapham, unidentified, and Myrtis Porcher.

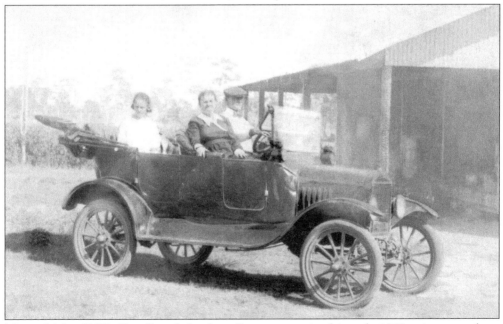

Mr. and Mrs. H.W. Harrell and daughter Rena appear in this early 1900s picture made at Sunset Groves, located between Indianola and Courtenay.

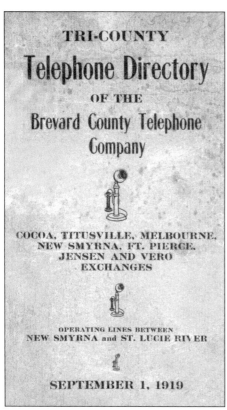

The Brevard County Telephone Company was in existence in 1905. In 1911, Merritt Islanders John Reed and A.A. Buck acquired the telephone company and installed a cable across the Indian River to the mainland. Pictured is the front of the 1919 directory billed as a "Tri–County" Company, operating lines between New Smyrna and St. Lucie River with exchanges at Cocoa, Titusville, Melbourne, New Smyrna, Ft. Pierce, Jensen, and Vero. According to the list of rules and regulations in the book, "Subscribers will be charged for messages sent by or for non-subscribers from their telephone" and "Conversations are subject to a limit of five minutes." General offices were located at Indianola. A.A. Buck was superintendent, D.S. Nisbet was president, C.D. Provost was vice president, and J.E. Reed was secretary and treasurer.

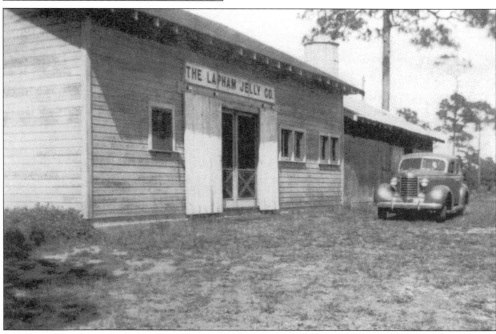

Known worldwide was the Lapham Jelly Company, Indianola, Florida, started by Jalma Lapham in 1898. The business prospered and was expanded by Lapham's son-in-law A.G. "Fred" Humphrys.

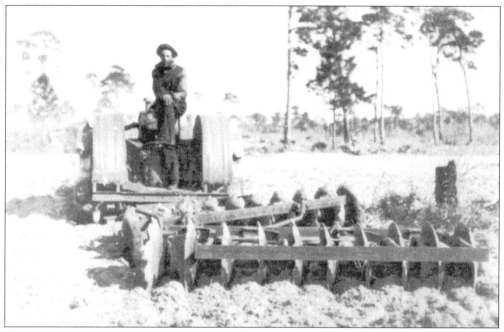

These people are preparing land to plant groves in the late 1930s A smaller version of a disk with smooth blades was used in the groves at this time, replacing the larger mule-drawn disk with scalloped blades.

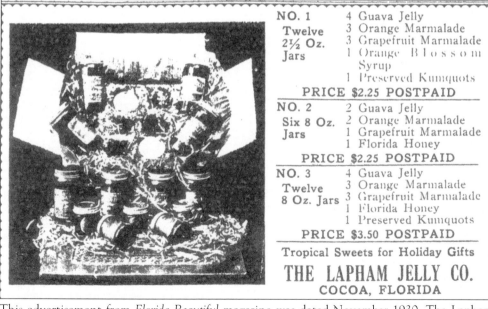

NO. 1 Twelve 2½ Oz. Jars	4 Guava Jelly 3 Orange Marmalade 3 Grapefruit Marmalade 1 Orange Blossom Syrup 1 Preserved Kumquots
PRICE $2.25 POSTPAID	
NO. 2 Six 8 Oz. Jars	2 Guava Jelly 2 Orange Marmalade 1 Grapefruit Marmalade 1 Florida Honey
PRICE $2.25 POSTPAID	
NO. 3 Twelve 8 Oz. Jars	4 Guava Jelly 3 Orange Marmalade 3 Grapefruit Marmalade 1 Florida Honey 1 Preserved Kumquots
PRICE $3.50 POSTPAID	

Tropical Sweets for Holiday Gifts

THE LAPHAM JELLY CO.
COCOA, FLORIDA

This advertisement from *Florida Beautiful* magazine was dated November 1930. The Lapham Jelly Company was located at Indianola and was famous for its guava jelly. This company was a source of income for local people for many years.

Pictured here is the Merritt Island Barge Canal Bridge shortly before it was replaced by a new version, which was opened in May 1955.

This is a May 1964 view of the Emory L. Bennett Causeway, which spans the Intracoastal Waterway. The causeway is named for a local Congressional Medal of Honor recipient who died June 24, 1951, holding off an overwhelming band of North Koreans, while his compatriots ran for safety.

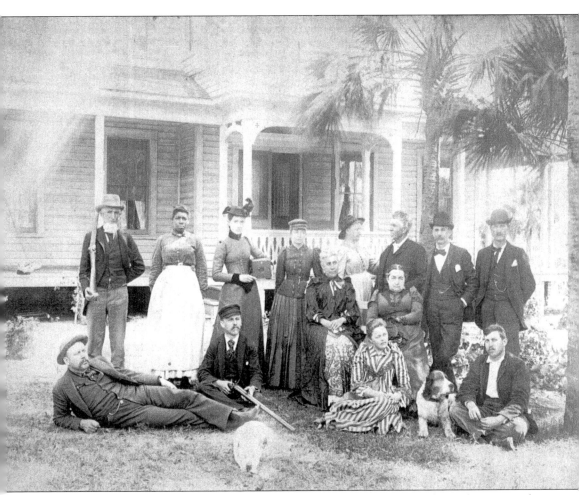

The tourist season has arrived! By the turn of the 20th century, railroad travel to Brevard County was possible and with the coming of railroad came visitors, invalids, sightseers, and adventurers. Here a Christmas party of Pennsylvanians and New Yorkers visits Dr. and Mrs. C.L. Hill in 1902. Shown, from left to right, are as follows: (front row) Dr. G.E. Hill, John Fritz (Scranton), Mrs. ? Scott (Scranton), Jennie Hill, Aunt Charlotte (Aunt to C.L. Hill) (New York), and Dr. C.L. Hill; (back row) Ephrum Hoos (brother of Celia Hill), maid, unknown, Celia Hill (mother of C.L. Hill), Mrs. ? MacDonald, Mr. ? MacDonald, Mr. ? Scott (Scranton), and John Reed.

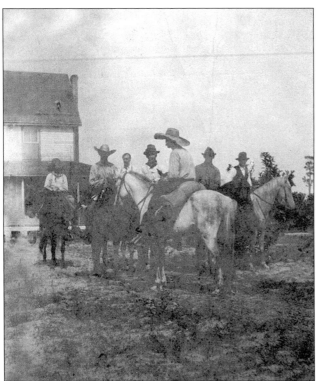

The raising of cattle was one of the main industries on Merritt Island during the early settlement era. A fence was strung across the island near Georgiana and cattle roamed free north of this point until a "no fence law" was passed. This law meant that the cattle had to be fenced because they were destroying the groves and gardens. Here we see a branding pen and cow hunters gathering for a round up.

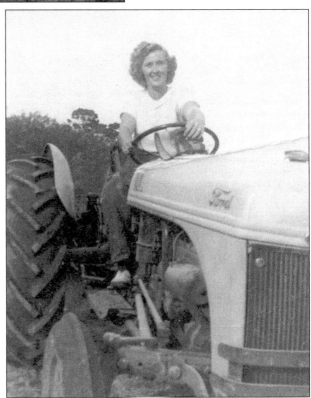

Volamae Roberts Brinkley shows that she is a big time operator as she maneuvers this vintage Ford tractor in the 1940s.

Three
THE MERRITT CITY AREA

Merritt City, once a thriving independent community located across the Indian River from Cocoa, no longer exists as a separate city. Ironically, however, the same area is one of the busiest commercial areas in Brevard County. As Cocoa Beach developed into a resort area in the 1950s and 1960s, the road connecting the mainland with the barrier island town was widened. Many of the older buildings associated with Merritt City fell to the wrecking crews. Shopping malls and strip malls replaced the individual businesses, while chain stores and fast food outlets robbed the area of its identity.

Despite the loss of a distinctive physical identity, Merritt City remains a reality in the memories of its former residents. Where asphalt and concrete now obliterate dirt roads and wagon ruts and where the formula-driven architecture of glass and concrete blocks work mightily to produce an *ersatz* version of Addison Mizner's Florida, old timers fondly recall the real Merritt City that reflected the personalities of its first settlers. In their memories, the used car lots and tuxedo rental stores are no more, replaced by the more substantial buildings of yore.

Recently, the Merritt Island Redevelopment Authority has inaugurated a program to refurbish and revitalize the small 1920s neighborhoods that made up the residential area of Merritt City. Broad, tree-lined avenues, irrigated by reclaimed water from nearby Cocoa, are hidden away from the hustle and bustle of traffic on Highway 520 like small gems waiting to be discovered. Along the Indian River shore, thick, tropical foliage hides multi-million dollar homes and large estates, while frenzied shoppers ignore the historical possibilities of this area, and tourists by the hundreds join them in a lemming-like race to the ocean. Left and right, the blight of poorly maintained commercial buildings blocks out the preservation revival that is taking place.

But once

MERRITT CITY

Merritt City, located on Merritt Island opposite Cocoa on the east bank of the Indian River and connected with Cocoa through a bridge, is one of the coming cities of this section. Many businessmen of Cocoa are making their homes in Merritt City, while rich citrus groves invite fruit growers and farmers. The town will be incorporated some time this year. Post Office—County rd.—J. A. Brabham, postmaster.

*A M E Church Rev John Reed pastor
Allen E W
*Anderson Doc (Mamie) fish
*Anderson Emmett lab r Doc Anderson

*Anderson Pope (Julia) restr
Bach Chas W (Lucy) civ eng h Beach rd
*Baptist Church Rev W W Willis pastor
Bass Donald C (Carrie)
Beckman Lewis (Constance) carp h Beach rd
Belt J H
Beyer Irene G (wid Chas H) r P K Gable
*Bishop Geo (Oveda) lab
Bishop Henry (Georgena) carp h Beach rd
Bishop Peter (Hattie) mason h Beach rd
Boa Thos P (Harriet)
*Bohman Susan
Bourne Faith student r F N Bourne
Bourne Fredk (Alice)
Bowman Oscar
Brabham J A & Co (J A and Laverne Brabham) gro and meats County rd

Brabham John A (Susan N; J A Brabham & Co) and postmaster h County rd
Brabham Laverne (J A Brabham & Co) r J A Brabham
Cawthon C Thos carp
*Christopher Frank (Lena) lab
Cleveland Chas
*Colored Public School Nettie Harold tchr
Cone Clarence student r W S Cone
Cone Wm S (Louise) carp
Cullen Alex F (Lulu) slsmn h DeWitt Apts
DeWitt Apartments Beach rd
DeWitt Mohr & McLelland (R L DeWitt, M M Mohr, J H McLellan) real est Beach rd
DeWitt Roland L (Rose L; DeWitt Mohr & McClelland) h Beach rd and McLeod
Donley Albert E (Donley & Hughey)
Donley & Hughey (A E Donley, H D Hughey) real est Beach rd
Donovan John mgr Lone Palm Grocery r do
Downam Harry (Martha)

Drewe G A
Dunham Edw H (Mary A) real est 25 Palmetto av do
Edge John H (Eva) plstr h Beach rd
Evans Chas T
Fairchild Della M (wid Roy)
Ford W Harold mgr Suniland Realty Co
Frey John
Fuegner F E
Furman Albert student r G B Furman
Furman Geo B (Bessie) fishermn h County rd
Furman Geo B jr student r G B Furman
Gable P K (Ella J) fruit grower
Garrison Etta M r Ralph Garrison
Garrison Ralph (Marian) auto mech Merritt Islan Garage h Pine
GAST FLOYD C (Lurlah; Merritt Island Garage)
Gast C Burdell auto mech Merritt Island Garage
Gast H E contr 25 Palmetto av h Merritt Park

Shown is a listing of Merritt City residents from a 1926–1927 directory

Gast Wm E (Etta) mech Cocoa Millwork Co h Beac
 rd
Gayton Archie real est h Pine
Gibbons Douglas J (Abbie) real est
Gibbons Thos B (Sallie) fruit grower
*Gillins Hannah r Lottie Peek
*Gillins Harry (Gladys) lab
*Gillins Mattie nurse r Lottie Peek
*Gillins Paul (Jessie) lab
*Girley Geo (Della) lab
GLASS H (Elsa T), Realtor 25 Beach Road, Phon
 3102, h Indian River north of Beach Road
Glattli Frank civ eng r H W Wilson
Golden Loa (wid Jas) r Henry Bishop
*Goss Alex J (Lillian) lab
*Goss Wm (Ethel) lab
Grantham Geo A (Georgia) painting contr h Grov
Grosse Otto R (Eliz) real est
Habe Frank fishermn r G B Furman
Hall E V fruit grower

MERRITT CITY—Conty
*Hardge Jas (Clara) lab
*Hardge Julius r Thos Hardge
*Hardge Thos lab
*Harris Wm H lab r Pope Anderson
HEADLEY IRA H, Mgr Merritt Island Garage, r Mc-
 Leod Court
Headley Marion G clk Merritt Island Garage
Headley Max r W J Headley
HEADLEY WM J (Cecile; Merritt Island Garage), h
 McLeod Court
Herr Dick carp r W E Gast
*Hughes Jos farmer
Hughey H Douglas (Irene C; Donley & Hughey) h
 Indian River s of Beach rd
Huling Geo W (Pearl) h McLeod ct
Huling Helen r G W Huling
Huling Whitfield jr student r G W Huling
Huling Wm r G W Huling

Humphrey F G (Lena L)
*Jackson Albert (Nora) lab
*Jackson Caretha r Albert Jackson
Jackson Edgar truck driver r H C Rigsby
Jackson Jas J (Florence) lawyer r C W Bach
*James Dora lndrs r Wesley Sanders
Jameson Eliz (wid Robt) r O R Grosse
Jones Chas
*Jones Margt (wid Wm) r Doc Anderson
Keith Robt cement contr r E D Poe
Kline Theo h County rd
Koch Louisa (wid John)
*Lane Isam (Susan) lab
LaRoche Eliz bkpr Merritt Island Garage res Cour-
 tenay Fla
LaRoche Geo W (Bertha S) carp
Lone Palm Grocery (Harry White) County rd
Lucas Clarence E (Loue) marine contr
Lucas Lucy r C E Lucas
Lyman F H Mrs h Merritt Park

The directory listing
continues here.

McLelland J H (DeWitt Mohr & McLelland) h Mc-
Leod ct
*Major Plant M (Gussie) lab
Marschalk Pauline r H H Wilson
Merritt Hotel Orange av
MERRITT ISLAND GARAGE (I H Headley, W J
Headley, F C Gast), Chevrolet, Oldsmobile and
Pierce-Arrow Motor Cars, Sales and Service,
Accessories, Tires, Batteries and General Repair-
ing, Beach Road cor County Road, Phone 3103
(See page 23)
Miller Clarence W (Mabel) carp h Beach rd
Miller Lawrence linemn r C W Miller
Milton R C
Mohr Martin M (Flora N; DeWitt Mohr & McLelland)
h Beach rd and Grove
*Monroe Anna r Sidney Singleton
MontsdeOca Carnie student r W M MontsdeOca

MontsdeOca Cath r W M MontsdeOca
MontsdeOca Clifford student r W M MontsdeOca
MontsdeOca Clinton student r W M MontsdeOca
MontsdeOca Kline student r W M MontsdeOca
MontsdeOca Wm M (Margt) fruit grower h McLeod
ct
MOONEY CHAS N (Jennie L; C N Mooney & Co), h
Merritt Park
Moore Clara B real est Ocean h do
Moore Frances E
Moore Henry H (Sadie) clk Lone Palm Gro res Cocoa
Fla
Moore Lucy P
Moosic Jack lab r H C Rigsby
Morton C F (Lucy)
*Nelson Robt (Anna) lab
Nolan August h Beach rd
Osteen Oscar (Susan) lab
Page W Clayton (Florence) phys
PALMER SAM B (Martha H; Agent New York Life
Ins Co, Cocoa)
Pankey Wm (Anna) banker
*Peek Lottie lndrs
*Philips Wm (Caroline) lab r Albert Jackson
Poe Ephraim S (Daisy) carp h Grove
Poland Wm carp r M M Ramsey
Post Office J A Brabham postmstr County rd
Quinton Margt S Mrs h County rd
Ramsey E H r Beach rd
Ramsey Milton M (Lillie) gro and fill sta Beach rd
h do
Ramsey Milto nM jr lab M M Ramsey
*Reed John Rev (Mary) pastor A M E Church
Reeves Andrew lab r H C Rigsby
Rigsby H Clinton (Bessie) slsmn h Beach rd
Rigsby Ruby r H C Rigsby
Robinson Helen Mrs

The directory list
continues.

RUDESILL DICK (Nellie; A A Buck & Co), h Beach
 rd
*Rushall Jesse (Amanda) lab
Rutledge Ltuher B (Ethel) carp h County rd
*Sanders Wesley (Carrie) barber
*Sawyer Dennis (Rebecca) lab
Schofield Edgar
Shoup Cora H Mrs
Sims Wm L (Annie) real est h County rd
*Singleton Abr lab r Sidney Singleton
*Singleton Sidney (Sallie) lab
Smith Herbert I (Mildred F) fruit grower
Smith Oliva student r L B Rutledge
*Smith Sarah cook r Lottie Peek
Stokes A Obie (Mattie) lab h County rd
Stokes Horace r A O Stokes
Story Eliz r W A Story
Story Weston A (Ruth) electn Brown Electric Co h
 County rd
Story Weston A jr r W A Story

Sylvia Lonnie civ eng r H H Wilson
Tawney Chas W
Taylor W O
*Thomas Corinne (wid Edw) lndrs
*Thomas Geo lab
Thomas M C
Thurman Phillip student r T O Thurman
Thurman Myralene student r T O Thurman
Thurman T Other (Addie) carp h Pine
Thursby Louis fruit grower
Townsend John W (Jessie) fruit grower
Travis Frank (Florence) plstr contr McLeod ct h do
Travis Frank jr r Frank Travis
Verity Ephraim (Mary E) boat bldr
Verity Oscar mech r Ephraim Verity
Walters Bernard (Minnie) carp h County rd
Walters Minnie Mrs drsmkr County rd h do
*Walton John H (Corinne) lab
*Walton Lawrence (Lillian) gro
Warner H G
Webster Geo E (Lona) fishermn h Magnolia av
Webster Geo E jr fishermn r G E Webster
Webster Kath r G E Webster
White Harry (Lone Palm Grocery)
Whittington Jas A (Lotus) grove mgr
Whittington Jas K lab r J A Whittington
*Williams Alex lab
*Williams Isaac lab
*Williams Lucille lndrs r Sol Williams
*Williams Sol (Mattie) lab
*Williams Spencer (Gussie) lab
Wilson Allen student r H H Wilson
Wilson Harold H civ eng
*Wilson Soloman r Isaac Williams
Wombsley John fishermn
*Woods Thos (Beatrice) janitor
Yates R Clark (Cath) slsmn h Beach rd
*Young Fred lab

The directory list continues.

61

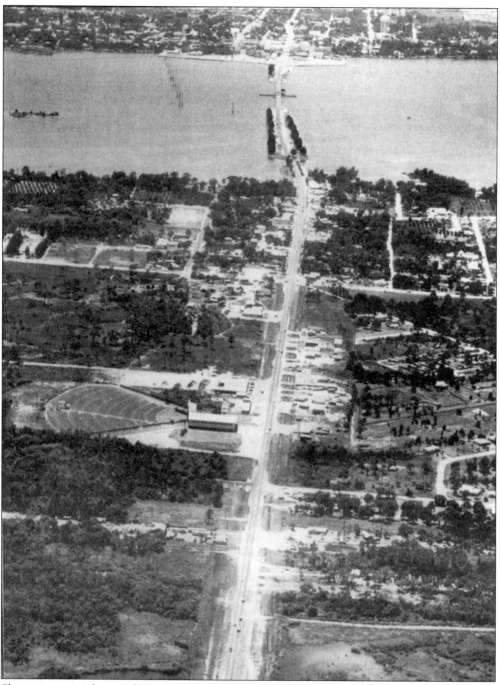

Shown is an aerial view of Merritt Island, looking west along Highway 520 on August 30, 1961. The Barn Theater and drive-in are on the left side of the picture.

On the left is Granger's Radio & TV and on the right is Crockett Electric. Pictured, from left to right, are Buster Jones, Leroy Lively, Jessie Granger, Leroy Granger, unidentified, Charlie Spooner, Ima Jean Blankenship, Perry Crockett, and two unidentified individuals.

Dennis Sawyer, a citizen of Merritt Island, always did his part in the Orange Jubilee Parade in Cocoa. Here he is shown driving his mule, which is drawing a wagon filled with his Merritt Island produce.

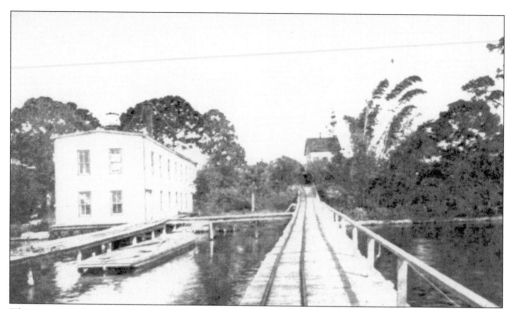

This view of the wharf at the Riverview Hotel on Merritt Island also shows the electric plant located at the hotel. Built in 1880 by Samuel Frost as a boardinghouse, the hotel was purchased by Thomas J. Nevins and operated as a modern hotel of 50 rooms in 1891.

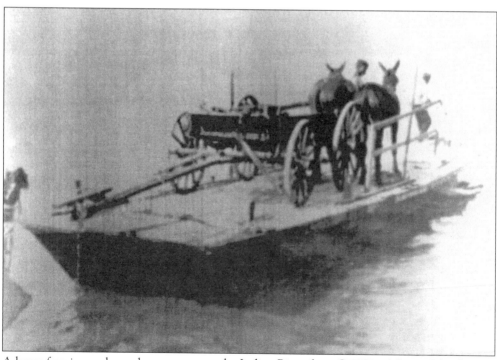

A barge ferrying mules and wagon crosses the Indian River from Cocoa to Merritt Island.

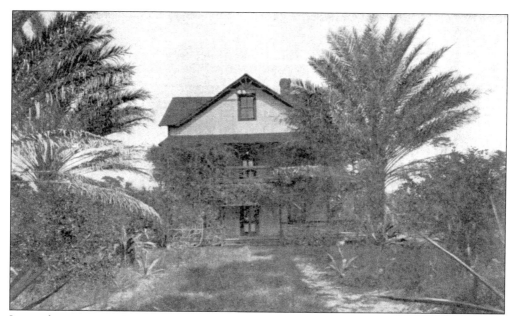

Located on Merritt Island north of present-day Highway 520 was the home of Col. L. Thursby. Colonel Thursby's niece, Miss Emma Thursby, was a successful opera singer both in America and in Europe. She contributed financially to the church hall at St. Mark's Episcopal Church in Cocoa, and in return, the church named the hall for her.

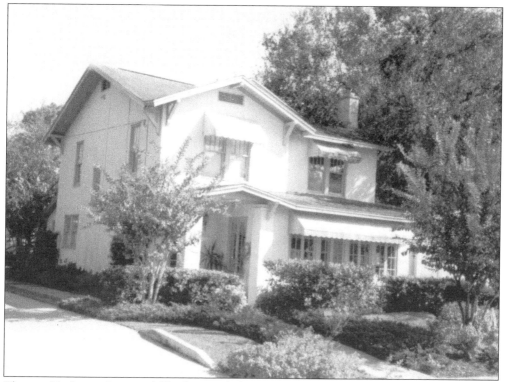

Thomas Blyth was the son of Charles O. Blyth and Nannie Sanders Blyth. Nannie Sanders had the distinction of being the first white child born on Merritt Island.

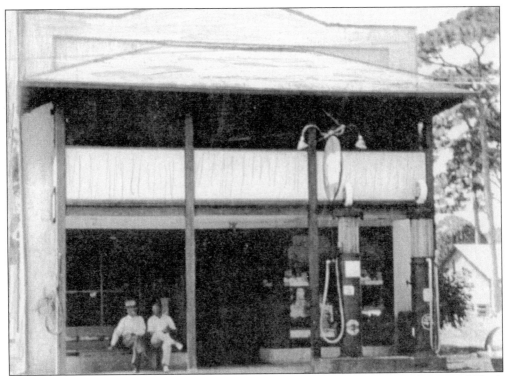

Brabham's Grocery was located a short distance north of Highway 520 on north Tropical Trail. Gulf gasoline was also sold by the Brabhams. Note the old-style gasoline pumps. Gasoline was pumped by hand to the glass container at the top of the pump, then put in the vehicle by gravity flow.

Marcellus Rambo Benson owned and operated a pharmacy and medicine supply at Merritt. Kathy Griffis Bishop poses here with the delivery van. As a high school student, Kathy worked the soda fountain.

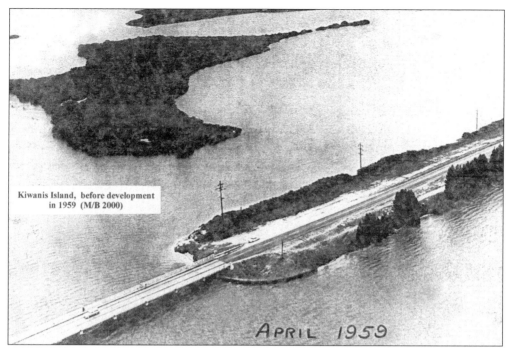

Kiwanis Island, before development in 1959 (M/B 2000)

APRIL 1959

Kiwanis Island, a Mangrove Island in Sykes Creek on the east side of Merritt Island, was developed into a recreational park by the Kiwanis Club. The project was started in April 1959. The first public event, a fish fry, was held on May 1, 1960.

A cartoon in the Cocoa *Tribune* announced the first public event at Kiwanis Recreation Island.

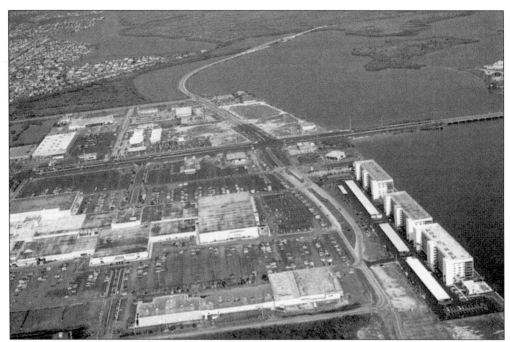

Here is Merritt Island looking north from Merritt Square Mall. Highway 520 is the road from left to right across photo.

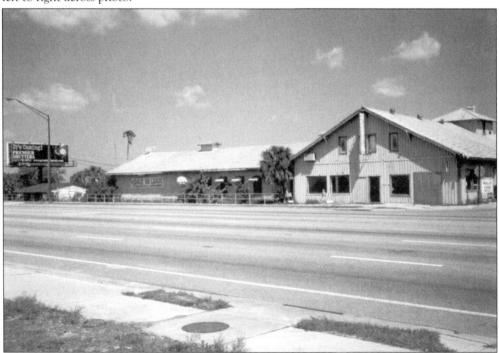

The Island Casino was located on Merritt Island. The left portion of this building was over the Indian River when originally built. Dredging and filling now has it on dry land, and the land and buildings past this building are toward the river. Vacant now, it has served as a bingo hall, skating rink, nightclub, and various other business endeavors.

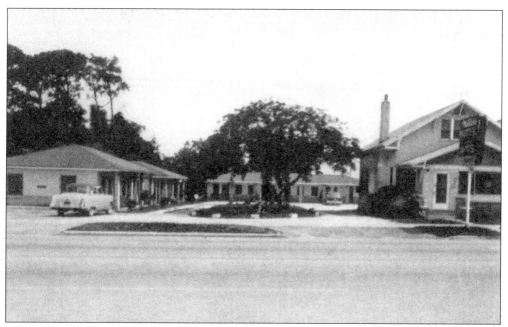

Miller's Motel, Merritt Island, later the Ping Pong Motel, and, at the present time, the Aladdin Motel, has progressed with the area's growth but remains a motel.

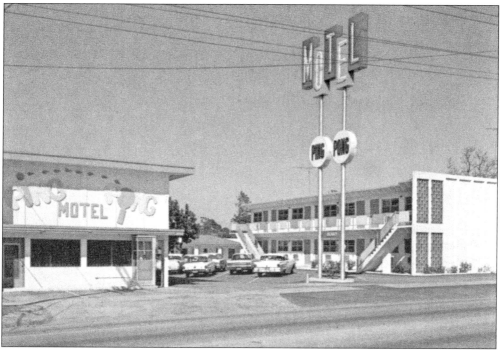

The Ping Pong Motel, Merritt Island, Florida, was at one time Miller's Motel. It was enlarged and named the Ping Pong. The motel is now the Aladdin Motel.

Early post offices in rural communities were usually located in a corner of a general store. This building may have had a triple use with living quarters located on the second story. A long walkway down to the river furnished a landing for the mail boat at Merritt.

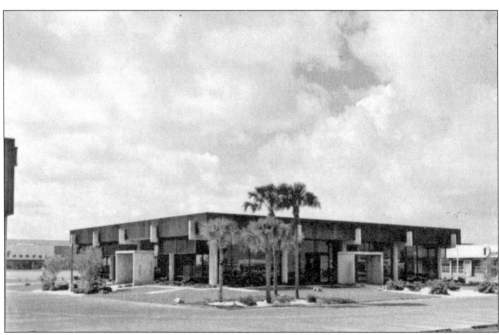

Built as a branch of Cocoa's First Federal Savings and Loan Bank at Merritt Square Mall, this location is now an Outback Steak House.

Four

SOUTH MERRITT ISLAND:

FROM HIGHWAY 520 TO DRAGON POINT, FOOTMAN, GEORGIANA, LOTUS, BRANTLEY, BANYAN, AND TROPIC

State Highway 3 now allows motorists to drive from the gates of the Kennedy Space Center on north Merritt Island to Dragon Point at its southern tip. The road from Highway 520 south is a meandering two-lane road that cuts through overgrown citrus groves, long-forgotten pineapple fields, and the edges of boggy marshes. At certain points along the drive, an alert observer can see both shores of the island. The same observer can also spot the hulks of abandoned grove houses, rotting under a relentless cycle of tropical showers and blazing sunshine, and the remnants of the numerous roadside stands that hawked Merritt Island citrus.

Overhead, buzzards circle endlessly in the lazy sunshine, seeking the leftovers from the meals of fish and rodents snared by the always vigilant ospreys, hawks, and bald eagles that stand like sentinels in the tall trees of Merritt Island "mahogany" that still survive in small stands. In the Indian River, mullet break the glassy surface of the water with loud and lively jumps into the air, while in the Banana River on the other side, the small dorsal fin of a porpoise appears and disappears as it goes about the business of feeding. Of course, many who drive this road never see any of this. For them, the highway is simply a means of moving from point to point, and they have little regard for what went on before they temporarily occupied this small time and space.

Just a few decades ago, the journey from the northern end of the island to the very southern point would have consumed several hours. Today, that trip takes only about 30 minutes, a trip through decades and generations at warp speed. In the short span of 20 minutes, it is possible to drive to the very place where a 50-foot green dragon, built several decades ago as a children's playhouse, crouches menacingly and glowers at passing boaters. From the lofty dreams of rocket scientists at the Space Center into the magical world of pre-history at Dragon Point, the ride is short, but filled with the ghosts of the recent past.

The litany of place names rolls off the tongue like an old-time railroad conductor's chant—Footman, Georgiana, Lotus, Brantley, Banyan, and Tropic!

FOOTMAN

Adjoining Merritt City on the south.

Allison John D r H E Beadle
Beadle Harry E (Verna) clk Logan & Fields
Bonsteel Richd E (Victor) mail contr
Booth Timey (wid D L) r J E Ramsey
Carpenter Stephen L
Cleveland Cath B r Chas Cleveland
Cleveland Chas fruit grower
*Davenport Florence r Jesse Davenport
*Davenport Jesse (Esther) lab
*Davis Wm P (Bessie) lab
*Elkin Anna
Fields John (Eva) fishermn r J E Ramsey
*Ford Matt lab
Gast Ceryle B (Nellie) mech Merritt Island Garage
Hill Herbert W (Emily A) carp
*Jameson Wm M (Cyntha) lab r W P Davis
Marshall Alfred student r Harry Marshall
Marshall Harry (Esther) pres Merritt Island Const
 Co h cor Tropical Trail and Island Beach Blvd
Merritt Island Construction Co Harry Marshall pres
 Geo F Wollner sec-treas contrs cor Tropical
 Trail and Island Beach Blvd
Ramsey Jos E (Mary E) farmer
Schofield Edw Capt
Scott Walter W (Helen I) plmbr

This is a listing of Footman residents from a 1926–1927 directory.

Footman Landing, pictured June 23, 2000, was named in honor of an African American who went there in the early days with a large boat that he chartered and also took fishing parties. He would take the boat back north in the summer.

Footman, an early residential community of south Merritt Island, regained a claim to fame when the Rotary Club recently added to the recreational opportunities for the entire county. The park features picnic facilities, playground equipment, and a playing field. Nature walks enable people of today to get an idea about what the area was like in yesteryear.

Pictured, from left to right, are Robyn Herman, Cicely Conway, Kathy Herman, and Sheamus Conway as they enjoy the playgrounds at Rotary Park. Footman, Florida, was west of the park on the river shore.

GEORGIANA

On Merritt Island, about 5 miles south of Merritt City. Some of the biggest citrus groves on the island are located in the immediate vicinity of Georgiana.

Allen Edw W (Frances) mgr Geo S Bruen Grove
Allen Jas W (Nancy) farmer
Allen Ruth clk r J W Allen
Allen Thelma r J W Allen
Anner Henry (Leeta S)
Bain Harriet F
Barker Wm (Levie) lab
Barrow R Ellason (Maud) sec Trafford & Field
Blackshear John
Bond Edna r Emily Bond
Bond Emily r Emily Bond
Bond Emily E
Bruen Geo H (Jennie) fruit grower
Bruen Horace R r G H Bruen
Burke Winifred housekpr r Emma E Robinson
Clement Waldo P farmer
Colbert Parker J prop Pelican Grove
Deese C A
Deese L H
*Elkins Chas S
Fry John L lab r W H Fry
Fry Mary E (wid J H) r W H Fry
Fry Wm H prop Fairyland Grove
Gibbens Thos B
Grantham Geo (Georgia) pntr
Hall E V
Hall Wm D (Anna P) truck driver
Hempstead Edw (Bess)
Hempstead Wm G r Edw Hempstead
Hess Kenneth M (Adelaide) r Edw Hempstead
Hill H W carp W H Bower
Jacqui Philip
Jones Sarah M housekpr r Waldo Clement
Lee Agnes (wid Herbert E)
Lindner John R (Kath) genl mdse
Lyman Lillie (wid Frank)
Lyman Rosalie r Mrs Lillie Lyman
Malphurs Perry E (Fanny) farmer
Miller H P
*Miller Louis lab
Munson Dell C (wid F W)
O'Hara Andrew B (Julia K) fruit grower
Peterson Frank (Mary) carp
Pierce Mary E (wid Fred)
Porter E L
Provost Gertrude
Reid Jas L (Athney) mgr L B Sandlers Grove
Robinson Emma E
Salvail V H (Mamie C)
Scott Geo J
Seelye Mrs r Agnes Lee
Sellers Christopher C (Pauline) lab
Sellers John lab r C C Sellers
Sellers Jos lab r C C Sellers
Sellers Saml O lab r C C Sellers
Sinclair Pearl farmer r Mary E Pierce
Smart R A
Thiers Louis M
*Trimmings Lawrence (Mary) pntr
*Williams Jos (Minnie) lab r Chas Elkins

Shown is a listing of Georgiana from a 1926–1927 directory.

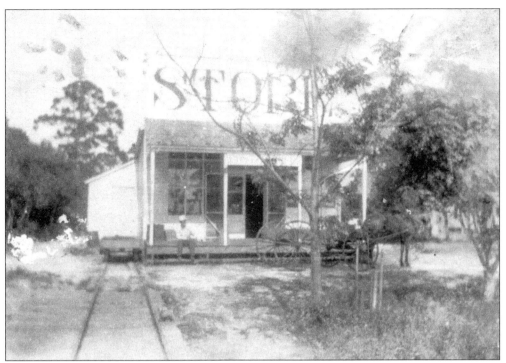

The C.D. Provost store was at Georgiana. Note the rails and flat cart on the left of the photo. Most docks with heavy traffic had these small rails to push carts out to the deep water.

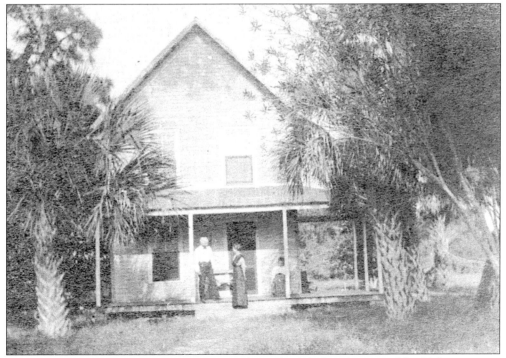

This riverfront home of the Joe Cannatta family was built before the turn of the 20th century in Georgiana. The Cannatta's were grandparents of Edward Field of Indianola.

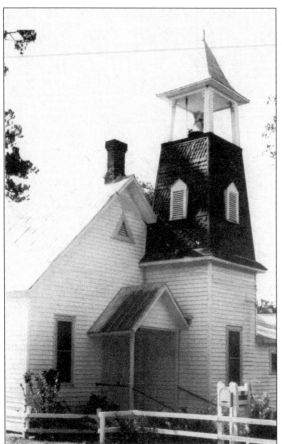

In the early 1880s, south Merritt Island settlers would gather for religious services at the homes in the area. Services were led by circuit riders and retired ministers. Soon, plans were made for a permanent meeting place, and a sanctuary was constructed from pine brought from St. Augustine by sailboat. The first service was held in the Georgiana Methodist Church on Thanksgiving Day of 1886. It was a day of thanksgiving, indeed!

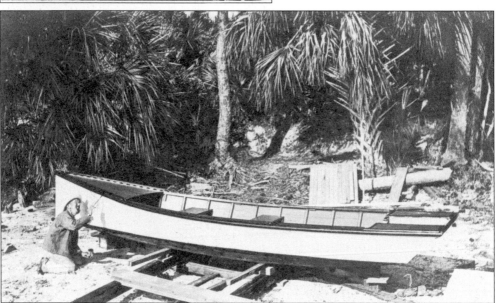

Pictured *c.* 1914 in Georgiana, M.F. Ulrich applies trim paint to the *Thetis,* a row and motor boat he built.

"Unique" is the word for this tombstone in the Georgiana Cemetery. There are no dates on the stone. The local story is that Mr. Chester, as a young man "up north," plowed with a mule, and this boulder was in the field. When he plowed up to the boulder, he would sit on it for a short rest and would say he wanted the boulder for a tombstone. He came to this area in the early 1900s. He died here, and his family had this stone shipped down for his tombstone.

Laurie Peterson, descendant of the Wittfields of Fairlyland Hill and Honeymoon Lake, sports the 1914 model of the latest convertible.

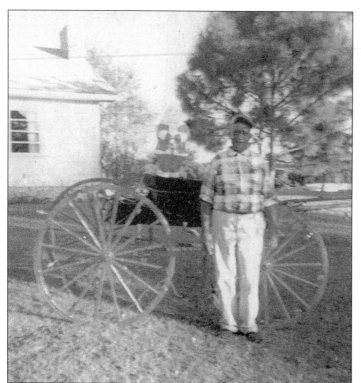

Was he Santa's helper, too? Most Merritt Islanders will recognize Booker T. Williams as Laurie Peterson's caregiver, but the Santa connection is unknown.

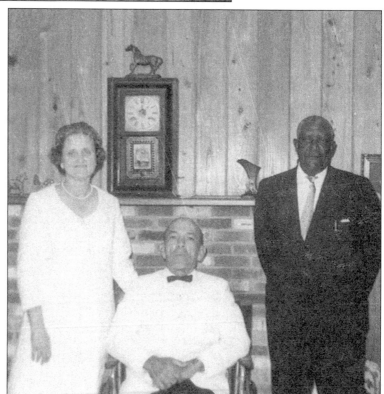

Margaret Peterson, Laurie Peterson, and Booker T. Williams prepare to go to Mrs. Stewarts's party at Hacienda del Sol.

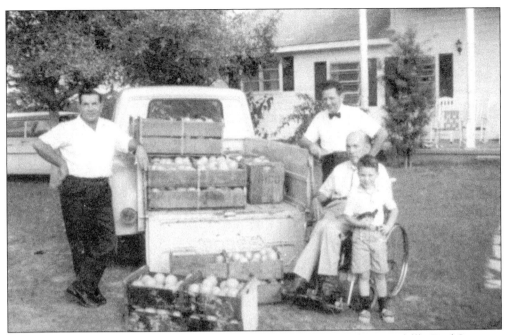

Shown on Thanksgiving weekend in 1967, from left to right, are John Crisifullli, Fred Spencer, Laurie Peterson, and Tim Spencer. Fred Spencer was a brother-in-law of Laurie Peterson. Fred served as Cocoa Beach city commissioner from 1959 to 1962. John Crisifulli was part of the well-known citrus family of north Merritt Island.

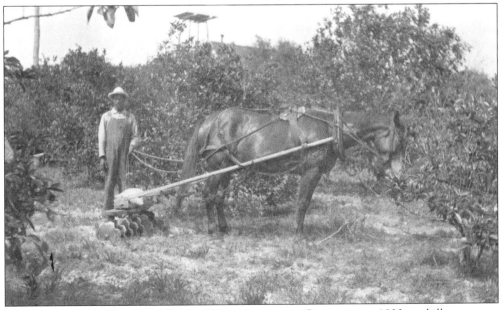

This picture was made in the Waldo Clement's grove at Georgiana, c. 1930, and illustrates an early method of harrowing the citrus groves.

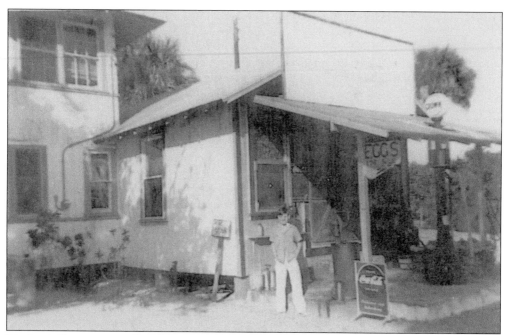

Lindner's Store, pictured in the 1930s, was located on the Banana River at Lotus. The house was attached to the left, and the boy standing in front of the store was Tommy Johns Waddell. This store's stock of gasoline and a few basic items was very helpful to people living at Lotus.

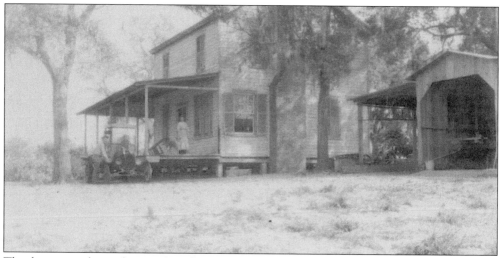

This house was located west of Lindner's store at Lotus. Edward and Susan Lindabury moved there just before the big freeze of 1895.

LOTUS

Located 8 miles south of Merritt City on Merritt Island in the heart of the Indian River Citrus belt Lotus is situated between the Indian and the Banana Rivers, fronting both waterways. Besides citrus fruit there are quite a few tomato and vegetable farms here.

Post Office—Mrs. Eva D. Osteen postmaster.

*Adderly Joel (Ethel) lab
*Adderly John lab
*Adderly Nathan (Emily) farmer
Atkinson John H
Autinrieb Fred (Marie) fruit grower
*Baumon Gaines (Sarah) lab

Brawner Chas lab
Brawner Sallie r Chas Brawner
Capron Jessie C r J M Leath
Chandler Hayne R lab r S A Osteen
Cuningham McLean (Louise)
Danner Gustave A fruit grower
Danner M Ella r G A Danner
Ensey E R
Gilman C B
Jerome Helen F r S M Leath
Johnson J Thos (Sula)
*Knowles Thos lab r John Adderly
LaRoche Benj B jr lab r Mary Stewart
LaRoche Danl r Mary Stewart
Leath Jas M (Lillian A) fruit grower
Lindabury Edw B fruit grower
Merrill H C (Marion A)
Morris Chas F (Alice) fruit grower

Morris Wm lab r C F Morris
Osteen Eva D Mrs postmaster
Osteen Saml A (Eva D) fruit grower gro and fill st
Pendarvis Arnold E (Maud) lab
Post Office Mrs Eva D Osteen postmaster Lotus
Powell Chas A

*Prosper Rosa r G Bauman
*Rigby Geo (Maud) lab
Schumacher Engelbert (Caroline) fruit grower
Schumacher Fredk lab r E Schumacher
Sellers C C
Sellers S O
*Smith Alfred (Christine) lab
Stewart Dorothy r Mrs Mary Stewart
Stewart Mary (wid R B)
Stewart Mildred r Mrs Mary Stewart
Stewart Nina r Mrs Mary Stewart
*Taylor Anna r W J Taylor
*Taylor Geo lab r W J Taylor
*Taylor Wm J (Martha) lab

Shown is a listing of Lotus residents from a 1926–1927 directory.

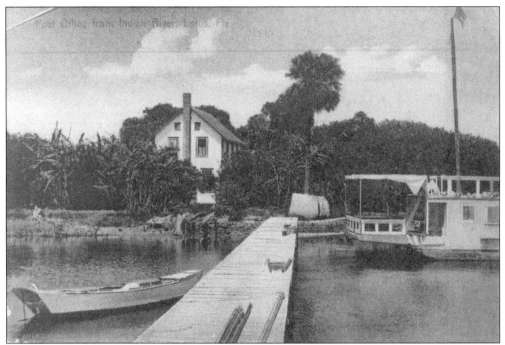

The estate of Sam and Eva Osteen was located at Lotus, Florida. Eva is listed as the postmaster in a 1926–1927 directory. This copy of an old postcard is labeled as "Post office from Indian River, Lotus, Florida."

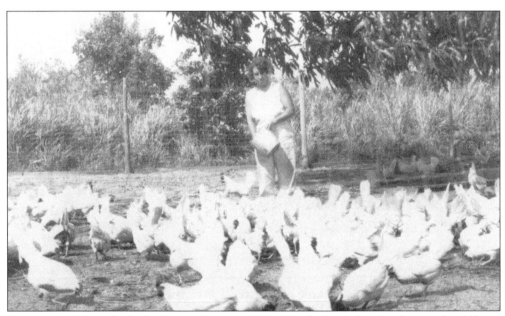

Florence Lindabury feeds chickens at Lotus, c. 1930. This flock of white Leghornes should have produced many eggs. The picture is representative of the transition from home flocks (ten chickens and a rooster) to today's egg farms where the chickens never touch the ground and are never in direct sunlight.

Arthur Salton, an internationally known artist and accomplished musician, was born in London, England. He married a Merritt Island lady, Louise Lindabury Rockerfeller, and settled here. He composed operettas, which were then produced, and he also painted pictures that are highly prized by their owners.

Arthur Walter Salton

Under The Auspices Of The Eastern Star

THE RAJAH
=== OF ===
GAYPORE

AN ORIENTAL OPERANZA
By ARTHUR SALTON
AT THE

Aladdin Theatre
COCOA, FLORIDA
FRIDAY, MARCH 25

MRS. JOHN D. SHEPARD, Soprano—MRS. N. F. REINER, Contralto
MR. ALBERT LUSSIER, Tenor—MR. EDWARD PECKENPAUGH, Basso
LARGE CHORUS OF COURT LADIES, DANCING GIRLS,
GUARDS, PAGE BOYS, ETC.
Under The Musical Direction Of Mrs N. F. Reiner

SPECIAL MUSIC, LAVISH COSTUMES, NEW SCENERY

New Dances Arranged By Mrs. Elizabeth Grosse Kinney
AN ENTIRELY ORIGINAL PRODUCTION. FIRST PERFORMANCE IN THIS WORLD

Arthur Salton's "operanza" titled *The Rajah of Gaypore* debuted at the Aladdin Theatre in Cocoa (now the Cocoa Playhouse) starring Marilou Shepard (Mrs. John D. Shepard). The choreography was by Elizabeth Jamieson.

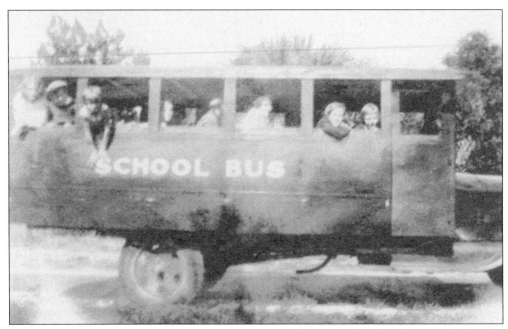

A mid-1920s bus transported south Merritt Island students to school on the mainland. This meant early rising to get to school.

This scenery was photographed on the Indian River.

TROPIC

On Merritt Island where the Indian River and the Banana River meet. Named after its tropical scenery.

Post Office—Geo. F. Ensey postmaster.
Allen Wesley carp r G F Ensey
Atkinson John H (Ella) fruit grower
Atkinson Marcus (May) fruit grower r J H Atkinson
Bailey Wm r J H Atkinson
Ensey Geo F (Minnie) postmaster
Ensey Marion T real est r G F Ensey.
McIntosh Chas W (Lula) lab r J H Atkinson
Merrill Henry C (Marion W) fruit grower
Post Office G F Ensey postmaster

Shown is a listing of Tropic residents from a 1926–1927 directory.

The Tropic Post Office was established May 26, 1884, and discontinued February 14, 1931, with the mail being sent to Lotus. This postmark is on the back of a registered letter that probably contained cash since it was addressed to W.G. Paterson, Cocoa. Paterson had a grocery store in Cocoa at that time.

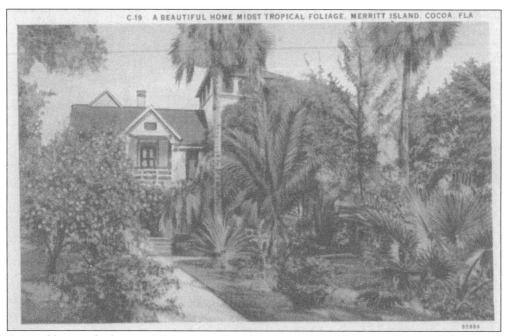

Pictured here is the house of Henry Merrill at Tropic. Mr. Merrill was a collector of plants, and it was on his property that the two-headed palm grew. Later, the house was converted to a nursing home—once known as the Tropic Nursing Home.

Freak Palmetto, Merritt's Island, Fla.

"The Two Headed Cabbage Palm," then the only known "freak" tree in existence—others do exist—was reported in *National Geographic* magazine, which stated it was impossible to graft artificially. The palm was located at Tropic on the grounds of the home of the late Henry Merrill. It was eventually destroyed by a hurricane.

This is the house at Tropic that was the home of Charles and Lula McIntosh and their son J.W. The small house sat on 12 acres of land where Mr. McIntosh grew tropical fruits that he sold in front of the house. After J.W. McIntosh died, the house was vacant for years and soon was overgrown with tropical vegetation. This picture was made in the summer of 1998 as the property was being cleared for development.

Mathers Bridge connects south Merritt Island to the barrier island to the east. The first Mathers Bridge was built by John D. Mathers and was a private enterprise undertaking. It formally opened June 16, 1927, with the owner collecting the tolls. Later, the bridge was sold to the Florida State Road Department.

The South Point of Merritt Island is shown here, with the end of the Banana River to the left. This point of land can be seen from the Eau Gallie Causeway. A dragon now rests on this point.

Shown here is the dragon at the southern tip of Merritt Island. The 67-foot-long reptile was crafted from 20 tons of concrete and steel by Lewis VanDecar in 1971. Warren McFadden bought Dragon Point in 1981. He hired VanDecar to add a long curved tail and four dragon hatchlings, christened Joy, Sunshine, Charity, and Freedom.

Five

THE WEST SHORE OF THE BANANA RIVER:

AUDUBON AND ANGEL CITY

Angel City and Audubon, located on the western shore of the Banana River, had short careers as official towns. Audubon, named in honor of great naturalist John James Audubon, had a post office for a mere 18 years, while Angel City's claim to this status lasted a brief four years. Despite their brief existence as "towns," Angel City and Audubon were clearly established in the minds of Brevard County residents. More than six decades later, natives orient themselves by using the two former towns as points of reference. At the annual reunion of the Brevard County "Mosquito Beaters," a group of native and near-native residents, it is difficult to engage in any conversation without some reference to these and other ghost towns in the area.

It is also difficult to understand why such small villages retain such a strong hold on the memories of former residents. The hardscrabble existence of all their residents, even the most affluent, meant lives of isolation and some deprivations—certainly in terms of today. Most former residents, however, focus on the positive aspects of life in Audubon and Angel City and downplay the more negative ones. "Life was hard," recalled one former Audubonite, "but it didn't kill us; it merely made us stronger." And if there is a single theme in all the stories told by those who lived in all of the communities on Merritt Island, it is just that. "If that is true," remarked one native wag, "we all should be Charles Atlas!"

The area surrounding Audubon, now a part of the Kennedy Space Center Complex, was an ideal hunting area for wild birds, and attracted numerous sportsmen. It also supported large herds of free-range cattle, at least until the opening of the Cocoa-Merritt Island Bridge in 1917.

Angel City, located south of Highway 520, served as the early gateway to the barrier island community of Cocoa Beach. Its location on the placid Banana River, like that of Audubon, made it an ideal "getaway" for hunters and fishermen.

AUDUBON

Situated on the Banana River exactly west o
the projected Canaveral Harbor. A big planing mil
is located here. Mrs. Edith S. Kelley, postmaster.

Banks Chas (Ida) pntr
Booth Marvin student r W E Booth
Booth Weedeman E (Etta) mgr Reynolds Grove
Burgland Gustave farmer
Bussler John J
Bussler Nelson
Callahan John A (Anna) phys
Curtis Chas jr student r C T Curtis
Curtis Chas T (Nettie) farmer
Dunden C R fruit grower
Fortenberry A (May) gro
Fortenberry Cubic student r A Fortenberry
Fortenberry Gordon student r A Fortenberry
Fortenberry Winfred E r A Fortenberry
Griffin R Louis
Griffith Chas (Mary) farmer
Griffith Marion fishermn r Chas Griffith
Griffith Thos fishermn
Grosmaire Frank cement wkr
Grosmaire Rose r Frank Grosmaire
Gutgsell Edw N
Harper Frank (Winnie) farmer
Harper Grover C (Dorothy) farmer
Healy John
Heist John R
Herron Oscar (Nellie) lab
*Jones Paul lab
Kelley Edith S Mrs postmstr r Leonidas Kelley
Kelley Francis T student r Leonidas Kelley
Kelley Fred E farmer r Leonidas Kelley
Kelley John B (Amanda) printer
Kelley Leonidas real est
Lollie Horace M (Jettie) mail carrier
Lollie Mason C r W W Lollie
Lollie Walter W (Amanda) fruit grower
Matchett John A (Ida) lab
Mathers Clem T (Viola) fishermn
Paisley Howard
Parrott Chas L (Cora) plstr
Perkins Saml P (Ethel)
Post Office Mrs Edith S Kelley postmstr
Sellars Hoke (Alma C)
Sellars Laura Mrs
Sellars R Lester (Ophelia)
Sellars R Wesley
Smith Henry F
Steller Fred L (Rada) farmer
Sumrall A B
Swanson A S
Swanson R L
Taylor E Wright lawyer at Cocoa
Treakle Jack R (Daisy) fishermn
Treakle Wm (Emma) fishermn
Walker Herman (Anna) transfer
White J Louis
Widden Noah (Lucie A) lab
White Wm C

Here is a listing of Audubon residents from a 1926–1927 directory.

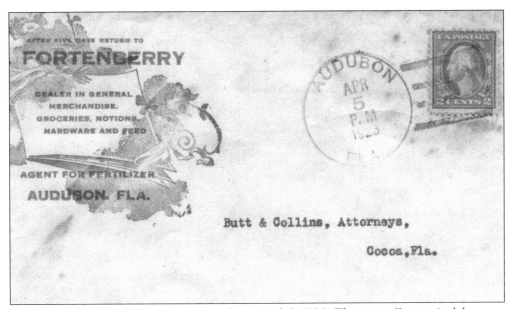

This postmark of Audubon was imprinted on April 5, 1923. The post office at Audubon was established on September 11, 1914, and closed on June 30, 1932. Mail for this area was directed to Cocoa.

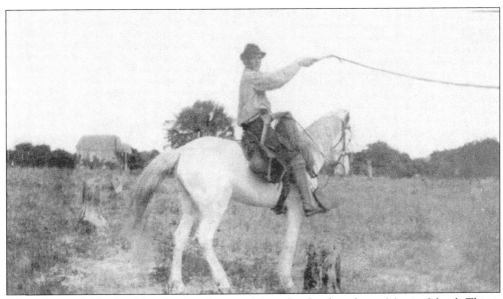

John Miot and Charles Cleveland each owned large herds of cattle on Merritt Island. This is probably a picture of one of their round-ups. Here we see a Merritt Island cow hunter cracking a cow whip to drive the cattle. The most popular version of the word "cracker" is from the sound of these whips. Loud pops or cracks of the whip were also used to signal neighbors.

This picture was taken, looking east on North Merritt Island at Hall Road. Audubon was located on the east shore of Merritt Island just north of Kars Park. The area is now included in NASA's property.

It has been said that the community of Audubon was named to honor John James Audubon, the noted naturalist who visited Florida in 1832 to study bird and animal life. Certainly, the area abounded in the wonders of nature, but today birds of a different variety soar skyward from these shores. In 1949, a law was signed by then President Harry S Truman creating the Long Range Proving Ground and Cape Canaveral as the testing site for guided missiles. Audubon was absorbed into the Space Center area and ceased to exist as a community.

Angel City on South Banana River Drive had a post office between 1927 and 1931. It is believed that the community was named for an early settler, John Angel. An Angel City postmark is rare, because of the short time the post office was in operation. Note that the postage was only 2¢ for a first-class letter.

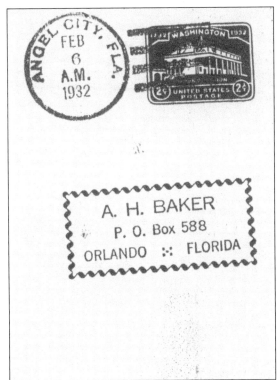

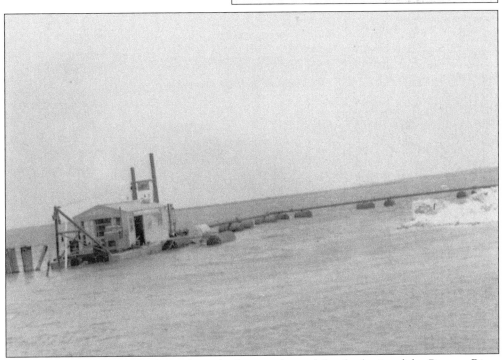

A 12-inch cutter dredge is shown here dredging a channel for the basin of the Banana River Marine. This same dredge, owned by the Inman Brothers, later was used to pump the land for Cape Canaveral Hospital.

Banana River Marine's Ship's Store is the owner of the drawbridge and marina. The road is South Banana River Drive, shown while looking toward the small drawbridge.

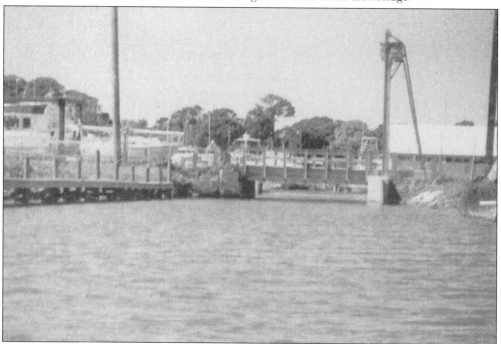

Shown here is the drawbridge at the entrance to the marina located at 1360 South Banana River Drive. The draw span is 22 feet, but it tilts to allow boats to enter and leave the marina. When in place, autos can use the road. The bridge was built in 1963.

This park is located at the Merritt Island end of the bridge across Banana River to Cocoa Beach. The Cocoa Beach end of the bridge connected at Minuteman Causeway.

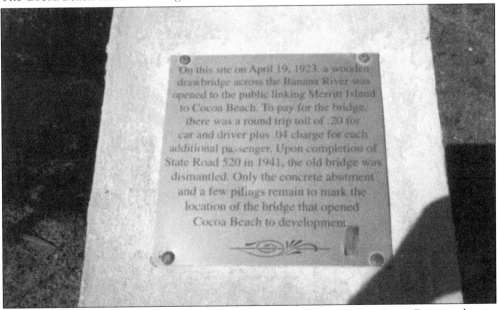

This is the plaque for the Banana River Bridge located at South Banana River Drive at the site of the bridge. It reads "On this site on April 19, 1923, a wooden draw bridge across the Banana River was opened to the public linking Merritt Island to Cocoa Beach. To pay for the bridge, there was a round trip toll of 20 cents for cars and driver plus 4 cents for each additional passenger. Upon completion of State Road 520 in 1941, the old bridge was dismantled. Only the concrete abutment and a few pilings remain to mark the location of the bridge that opened Cocoa Beach to development."

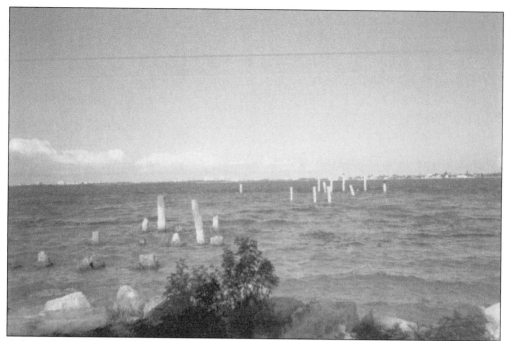

A few pilings of the old Banana River Bridge from South Banana River Drive to Cocoa Beach still remain, but ones in deeper water have been removed. In 1923, when the bridge originally opened, you could not see any buildings on the Cocoa Beach side.

This present-day photo, south of the old bridge site of Banana River Bridge from Merritt Island to Cocoa Beach, is typical of many Merritt Island and Cocoa Beach roads until 1950 when the missile and space programs brought "exploding" progress to the area.

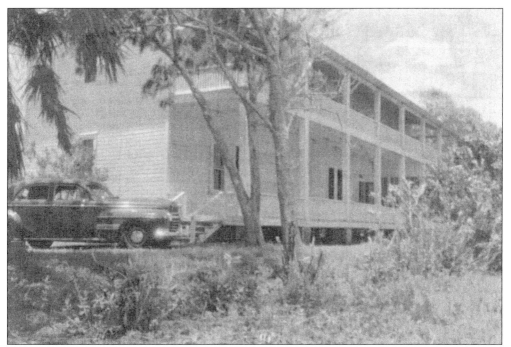

"Tamarind" is the name given to this building by Marie Holderman when she owned it. Originally, it was built as a hunting lodge on the south Merritt Island. The building is now owned by the Citrus Council of Girl Scouts.

Here is a present-day picture of Tamarind, an old hunting club located south of the bridge site on South Banana River Drive. A steel fire escape was added when the building was converted to a Girl Scout building.

A large room at Tamarind is shown here. Many people are probably proud that these walls are only beautiful and can not talk.

The Tamarind inside stairway was originally built about 100 years ago.

Six

THE BEACH SIDE OF THE BARRIER ISLAND:

CANAVERAL, ARTESIA, COCOA BEACH, OCEANUS, AND PATRICK AIR FORCE BASE

The barrier island that guards the Indian River Lagoon from the ravages of the Atlantic Ocean is a study in the diversity of community growth in Central Brevard County. Canaveral, located immediately adjacent to Port Canaveral, takes its name from the Spanish designation of the nearby cape as the "Cape of Canes." Canaveral is the oldest place name to appear on maps of the North American continent, but the town of Canaveral is among the youngest towns in the county. Centered originally around the solitary lighthouse on the cape point, residents of Canaveral were few. The development of Port Canaveral and the Kennedy Space Complex accelerated the growth of the area in the 1950s and now dominate the skyline. Clusters of condominiums, small and large residences, and ubiquitous strip malls constitute the town proper. Yet, Canaveral maintains a sense of pride in its history as witnessed by the efforts of local author Ann Thurm.

Artesia was another small community located on the beach side of the barrier island. Many of the residents of the town made their way each morning to businesses they operated or worked for in Cocoa, Rockledge, or Titusville.

Cocoa Beach was the product of visionary Gus Edwards, a native Georgian, who settled in Cocoa in 1917. Enamored with the vast scenic expanses of the barrier island, Edwards promoted the area throughout the United States. Although the 1920s and 1930s saw little in the way of substantial development of present-day Cocoa Beach, World War II and the coming of the Space Center in the 1940s and 1950s gave substance to his dreams.

Patrick Air Force Base, originally constructed in 1939 as the Banana River Naval Air Station, has played a significant role in the economy of Central Brevard County. In addition, the link between Patrick and the Space Center has thrust the area into the forefront of the technological revolution of the last half-century. The base has also been the "jumping off point" for American military activities in the Caribbean and Latin America. County residents pay little heed to the huge cargo planes that lumber along invisible highways in the sky or to the noisy formations of sleek fighters jetting off to unknown destinations for even more secret purposes. Nevertheless, the base has been integrated into the civic landscape of the county.

CANAVERAL

Located between the Banana River and the ocean, about 10 miles north of Cocoa Beach, Canaveral is one of the oldest settlements in this part of Florida. The government light house is located in this vicinity. A big and modern harbor is planned for Cape Canaveral. J. J. Jeffords, postmaster. Canaveral light house—Capt. Clinton P. Honeywell, keeper. Canaveral school—Eliz. F. Evrard, teacher.

Arton Margt M Mrs
Arton Paul lab r Mrs M M Arton
Atkisnon Quincey E lighthouse kpr r Capt C P Honeywell
Breuning L F (Laura)
Burns Kath student r R C Burns
Burns Meridith student r R C Burns
Burns Robt C (Bessie M) real est
Canaveral Harbor Lodge Mrs Ruby Marks mgr Canaveral Harbor
Canaveral Public School Eliz F Evrard tchr r C P Honeywell
Chaplain Mary F r Chas Lansing
Clapp Glenn lab
Coleman Rufus (Margt) farmer
Creel Jessie B
Crocker Louis carp r Jas Merchant
Crowder J Ivan (Iva)
Davis Frank carp
Davis Leonard carp r Frank Davis
Davis Nora r Frank Davis
Easterlin John L (Busie J) farmer
Erickson M W farmer
Evrard Eliz F tchr Canaveral Public School
Foley Jos E (Alice) farmer
Gerry Wm L (Irene G) slsmn Lansing & Stillman h Canaveral Beach
Greenlaw Margt Mrs
Hall Frank A (Ida) farmer
Holmes Beatrice student r H L Holmes
Holmes Howard L farmer
Honeywell Clinton P Capt (Gertrude) lighthouse kpr
Honeywell Clinton P jr student r Capt C P Honeywell
Honeywell Florence student r Capt C P Honeywell
Jandreaux Chas (Vida) farmer
Jandreaux Lawrence r Chas Jandreaux
Jandreaux Nicholas r Chas Jandreaux
Jeffords Julius J (Florence A) post master
Jeffords Saml L (Kath)
Joselin Wm r G N Kimble

Kight Edw L (Lorten)
Kimble Geo
Kincaid Bert W (Bertha)
King Thomas Y carp
King Waneta r Chas Jandreaux
Lansing Chas (Mabel; Lansing & Stillman, Cocoa)
Lewis Wm B mech
Lohr Ernest
Marks Ruby (wid B O) mgr Canaveral Harbor Lodge
Merchant Jas W (Hazel) farmer
Miller Wm G r E L Kight
Moore Chas M (Phyllis) farmer
Moore Wm H (Mary C)
Morgan Kath
Norrell Percy R (Martha) farmer
Norseworthy Wm (Mary) carp
Post Office J J Jeffords postmaster
Quarterman Oscar F (Florence) lighthouse kpr
Rasmussen Marie Mrs
Robinson Frank C civ eng C A Inskeep
Siskind Marcus
Spies John mail carrier
Stewart John C
Swanson Ralph (Gertrude) artist r O F Quarterman
Syfret David (Eliz)
Syfret Florida r David Syfret
Syfret Hubert r David Syfret
Syfret Nellie student r David Syfret
Terryn Chas A farmer
Tucker Elmo lab r W A Tucker
Tucker Wm A (Flora) farmer
Turner Martha D student r Mrs Ruby Marks
Turner Regna E student r Mrs Ruby Marks
Wakefield Anna
Wakefield Gailand r Anna Wakefield
Wakefield Hazel r Anna Wakefield
Wakefield Rosa Mrs r Anna Wakefield
West Thomas Rev
Whidden Allie (Grace) carp
Whidden Jean gro
Whidden Lena
Whidden Lionel clk r Jean Whidden
Whidden Lorena
Wiig Howard
Williams Jennie
Wilson Alfred B r F M Wilson
Wilson Frank M (Henrietta) farmer

The directory listing continues.

101

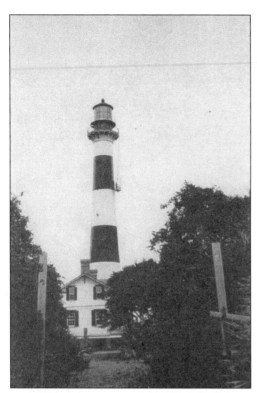

The Cape Canaveral Lighthouse is being painted by Morgan Ashley Ringo, who is in the basket on the right side of lighthouse. Mr. Ringo, a brother of Marie Holderman, homesteaded at what is now the entrance to Port Canaveral.

A defunct stock certificate of the Port Canaveral Terminal Company, dated June 11, 1926, was from a corporation that expected Port Canaveral to be completed many years before its actual formal dedication on November 4, 1953.

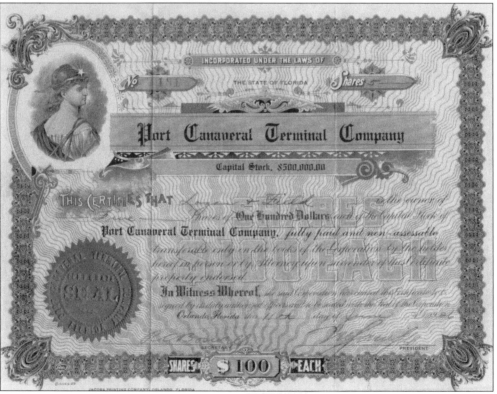

Uncovered turtle eggs are shown in a picture from 1919.

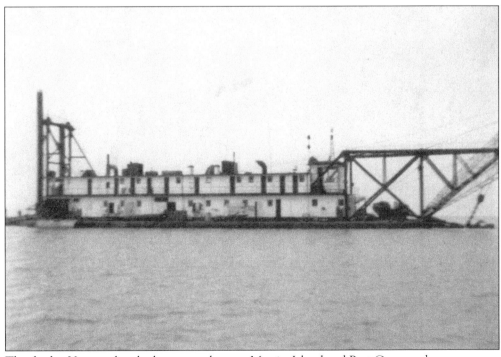

The dredge *Ventnor* dug the barge canal across Merritt Island and Port Canaveral.

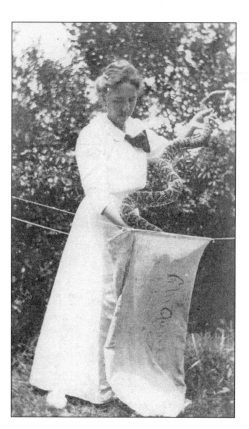

Mrs. Quarterman handles a rattlesnake with care. Capturing rattlesnakes was one method of earning additional money.

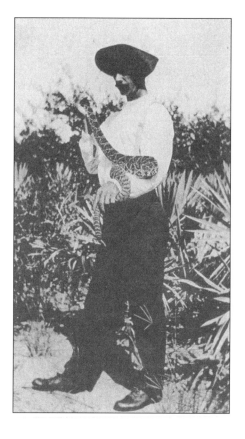

Oscar Quarterman is not to be outdone and exhibits another rattlesnake. Clara Bensen learned that many rabbits at the lighthouse community were kept to feed the rattlesnakes, which were shipped by boat to New York.

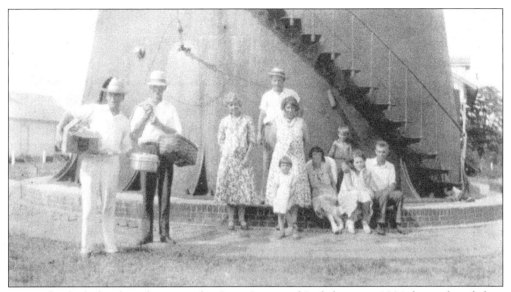

A Fourth of July family gathering at the Cape Canaveral Lighthouse in 1931 shows, from left to right, Sam Knutson, Wyatt Chandler, Bernice Chandler, and Wilkinson "Wink" Chandler. In front of Wink is Lorena Chandler Knutson, and in front of her is her daughter Nonie. Seated are Nellie and Wass Praetorius and their children.

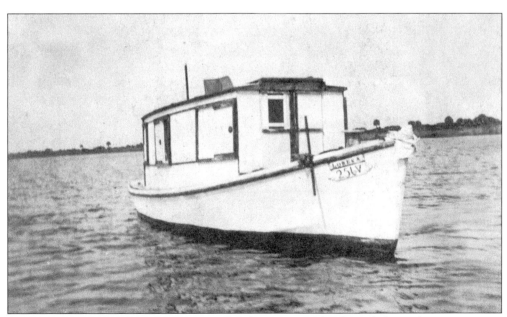

The *Lorena* was "family transportation" for the Knutson family and the early means to get supplies from the mainland before the bridge was built.

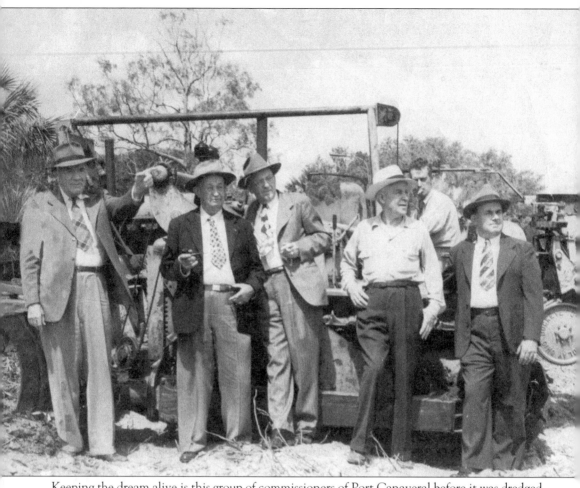

Keeping the dream alive is this group of commissioners of Port Canaveral before it was dredged. They are, from left to right, A. Fortenberry, R.L. "Uncle Bob" Geiger (Rockledge mayor), Noah Butt, Samuel Knutson, and Ben Lewis.

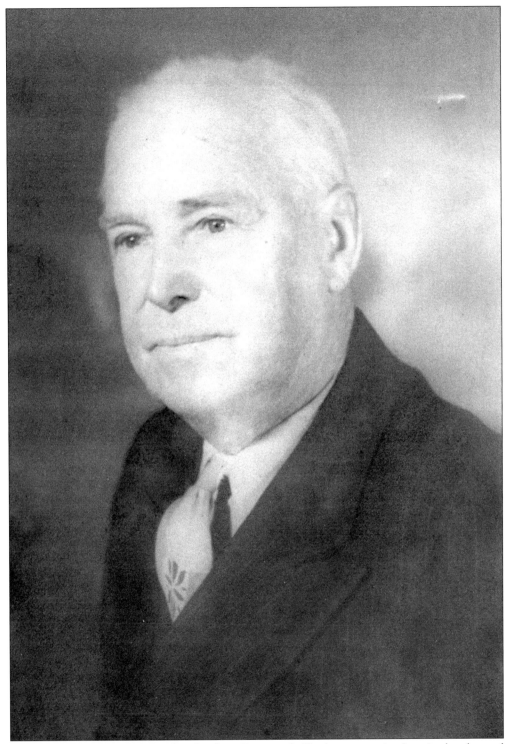

Samuel Knutson came to teach school at Canaveral. His home was in Artesia, but he and Harold Ford maintained a real estate office in Cocoa.

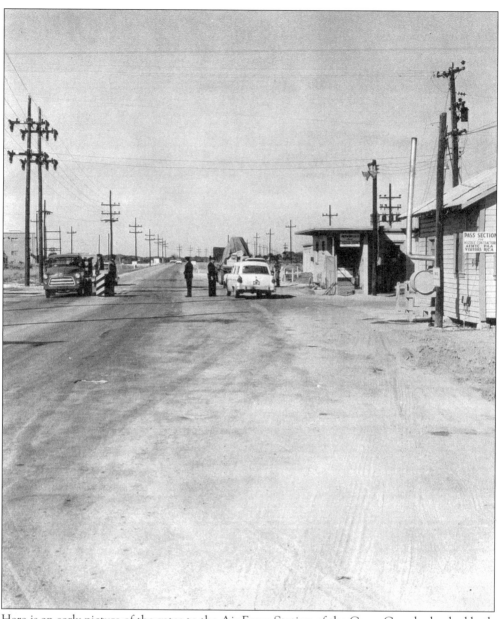

Here is an early picture of the gates to the Air Force Station of the Cape. Guards checked both incoming and outgoing vehicles.

Shown is a listing of Artesia residents from a 1926–1927 directory.

ARTESIA

On the Banana River, 7 miles north of Cocoa Beach. Mrs. Eliz. B. Eberwein, postmaster.

Artesia Public School Eliz J Eberwein tchr
Brown A H barber

Chandler Wilkerson fishermn
Chandler Wyaat (Bernice) fruit grower
Coulter Geo M (Brooke) fruit grower
Eberwein Eliz B Mrs postmstr r John Eberwein
Eberwein Eliz J tchr public sch r John Eberwein
Eberwein John (Eliz B) fruit grower
Eberwein Otto fruit grower
Eberwein Philip mech r John Eberwein
Eberwein Wm mech r John Eberwein
Parker Wilson
Post Office Mrs Eliz B Eberwein postmstr
Praetorious Albert M student r Edw J Praetorious
Praetorious Edw J fruit grower
Praetorious Edw R eng r Edw J Praetorious
Praetorious Waas fishermn
Praetorious Wm fruit grower
White Alice
White Wm mgr

This building was located just north of the present port. The Space Center took all the land that was Canaveral and the land north of old Artesia. The area was simply called Canaveral, a better-known name.

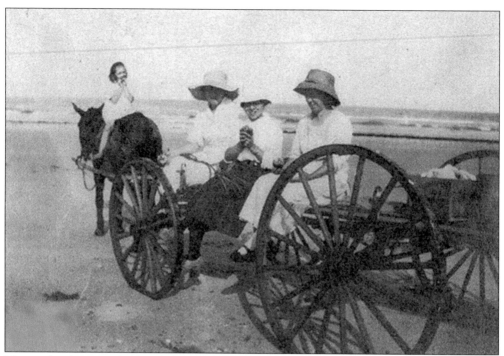

How is this for an early "beach buggy" picture in the Artesia-Canaveral area? The girl on the horse is riding backwards so as not to miss any of the conversation.

Elizabeth Eberwein is pictured in front of the Artesia Post Office on March 23, 1939. Mrs. Eberwein is the grandmother of Flossie Holmes Staton.

COCOA BEACH

Cocoa Beach, situated halfway between Jacksonville and Miami, is one of the pleasure resorts of the State. It is a long white strip of sandy shoreline protected from the currents by the arm of Cape Canaveral which extends out into the ocean. Its nearness to the Gulf Stream makes surf bathing comfortable throughout the winter. It has a wealth of vegetation and natural beauty, and is one of the safest beaches to be found anywhere.

Town Government

Mayor—Gus C. Edwards.
Commissioners—Jas. A. Haisten, E. L. Porter and Gus C Edwards
Treasurer—T. D. Jennings.
Clerk—Mrs. E. O. Pulsipher.

Post Office

Mrs. A. G. Jennings postmaster.
Cocoa Beach Development Co T D Jennings mgr
Cocoa Beach Hotel V S Schooley mgr
Courtleigh C R asst mgr Cocoa Beach Hotel r do
Davis B F (Gertrude)
Edwards Gus C mayor and real est
Haisten Arnold r J A Haisten
Haisten Jas A (Jennie) real est and town commissioner
Haisten Oliver r J A Haisten
Jennings Agnes G Mrs postmaster Cocoa Beach P O
Jennings Theron D (Agnes G) mgr Cocoa Beach Development Co and town treasurer
McCormick John J (Helen B) sec G C Edwards
PORTER EDGAR L (Ethel), Town Commissioner, V-Pres and Trust Officer Brevard County Bank & Trust Co
Post Office Mrs A G Jennings postmaster
Pulsipher Eva O Mrs town clerk
Pulsipher Frank J G (Eva O) real est
Schooley V S (Goldie) mgr Cocoa Beach Hotel r do
Tanner Warren C (Retta) mgr Gus Edwards Filling Station
Town Hall
Town Officials see Miscellaneous Dept
Wildeman J Fred slsmn F J G Pulsipher r do

This was once the post office building at Cocoa Beach. At left is Oliver Haisten, and at far right is Frank J. Pulsipher, the mayor of Cocoa Beach from 1934 to 1950.

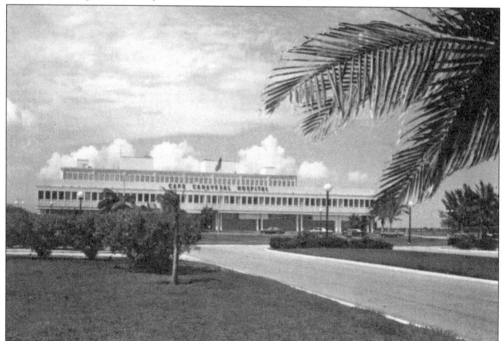

This building is named Cape Canaveral Hospital but is actually located on Highway 520 in Cocoa Beach. The land for the hospital was pumped in. Several additions have been made since this photo was taken.

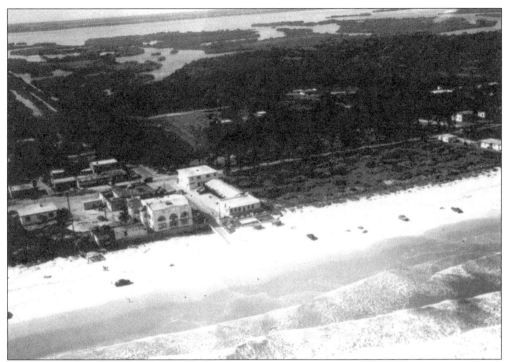

Shown in this aerial view looking west from the ocean is "downtown" Cocoa Beach in the very early 1950s. The building with the three arches is the Ocean Lodge, located between the ocean and Atlantic Avenue. Notice the Indian River, some of the Thousand Islands, and Merritt Island in the distance.

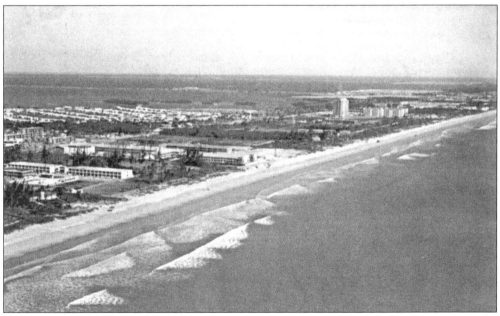

Growing pains yield results! By the 1970s, downtown Cocoa Beach had a different profile. Businesses and condominiums were beginning to line the shore and streets. The "Glass Bank" can be seen in the background. Some of the Thousand Islands are also being developed.

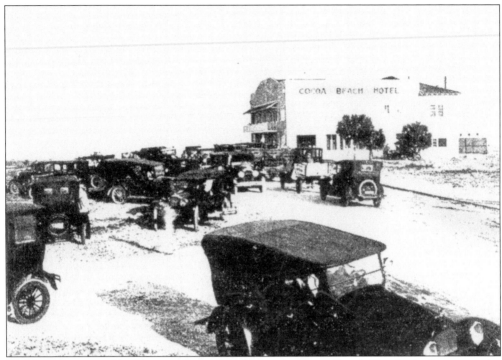

The first commercial building on Cocoa Beach was the Cocoa Beach Hotel, also known as the Casino. This might have been a holiday weekend.

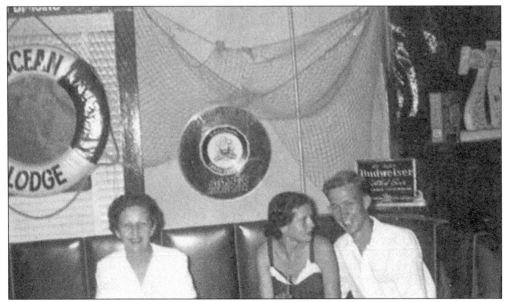

A rare interior view of Ocean Lodge includes, from left to right, Mrs. Anna Godke, unidentified, and Pete Godke.

In May 1951, the Cocoa Beach Chamber of Commerce sponsored a "Breakfast Fly-In." Seventy-eight planes and more than 150 pilots and passengers responded from all over Florida—Key West, Tampa, Orlando, Gainesville, Ft. Pierce, Vero Beach, Lakeland, and 15 other places. They landed on the hard surface and lined the beach to the delight of approximately 1,500 spectators.

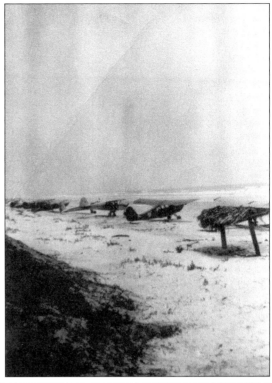

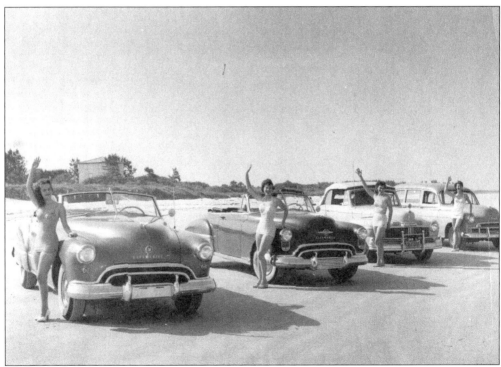

Welcoming the aviators were volunteer chauffeurs, identified from left to right as Marlene Minella, Evangeline "Angie" Hare, Helen Lane, and Anne Rahner.

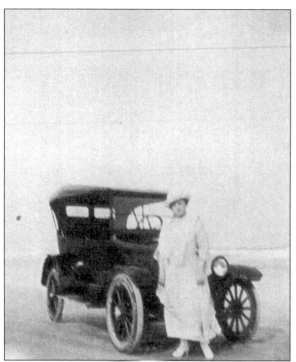

Grace Matteson is shown here at Cocoa Beach. The wide hard sands of the beach were great for a drive, and Grace's attire is more appropriate for riding in her air-conditioned car than for swimming.

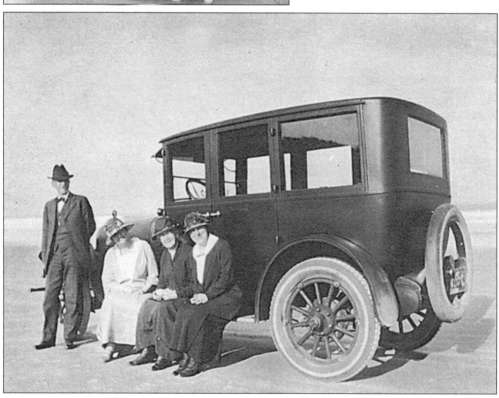

This picture was made at Cocoa Beach on March 26, 1924. The sand of Cocoa Beach at low tide was solid and hard as pavement.

Cars were driven on the beach at the east end of Highway 520. Notice the picnic shelter in the background—a popular spot for weekend visitors from inland Florida.

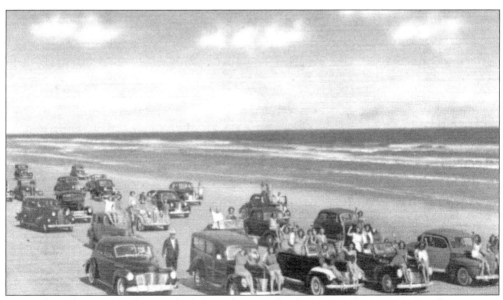

It must have been a Sunday or a holiday to have such a large crowd on Cocoa Beach!

California now has its Baywatch beauties, but Cocoa Beach already had a squad in 1950. Pictured, from left to right, are Maxine Rains, JoAnn Harvell, Cissie Brun, and Marlene Minella.

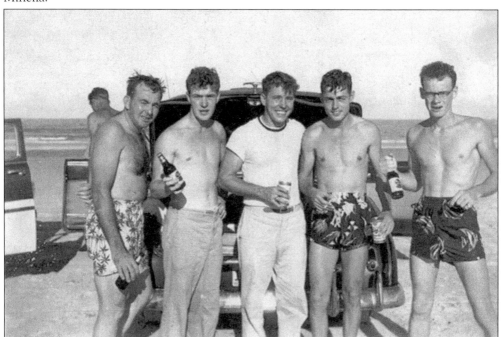

Here are the "Beach Boys" of the early 1950s. These "hunks" are posing at Cocoa Beach and flexing their muscles for the admiring girls. From left to right are George "Speedy" Harrell, Arthur "Ike" Isaccson, W.K. Fouraker, John Gray, and George Ackroyd.

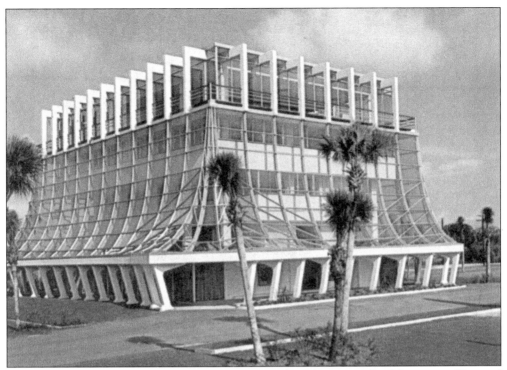

Cocoa Beach's skyline boasted an ultra-modern branch of the First Federal Savings and Loan of Cocoa. The building was locally referred to as the "Glass Bank."

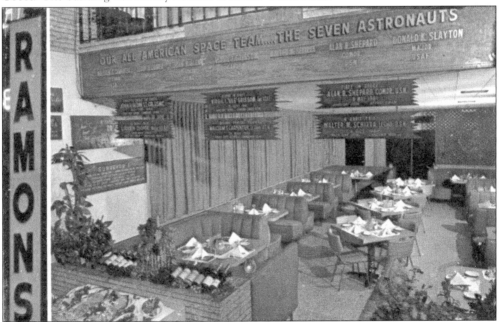

Don and Allene Holt owned and operated Ramon's on Highway 520 at Cocoa Beach. The restaurant was touted as a Golden Spoon Award recipient and honored the astronauts. It is no longer in business but people are still arguing about to whom the original recipe for their Caesar Salad dressing belongs.

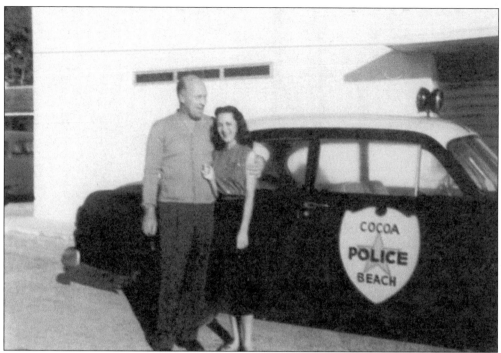

Thomas "Scotty" Caldwell, chief of police of Cocoa Beach, and Marlene Minella Wells are pictured here.

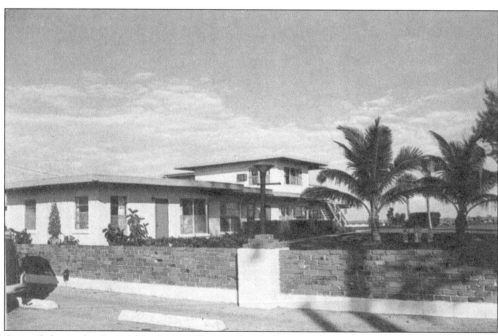

One of the early Cocoa Beach motels was Tinker-By-The-Sea. The "Tinker" was Ronald F. Tinker, who served as Cocoa Beach commissioner from 1958 to 1960. Baseball fans will be familiar with the "Tinker to Evers to Chance" play of the Chicago Cubs.

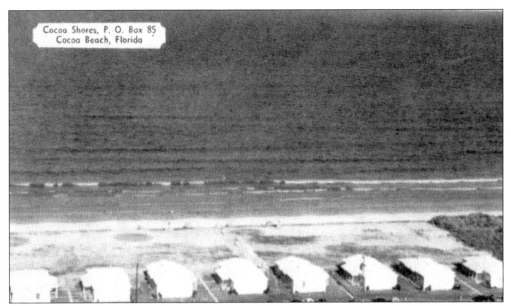

Many early motels and rentals were one story. They have been replaced with high-rises and condominiums.

It looks like "rub a dub dub," three women in a tub, but it's actually Mrs. Greenway, Margaret Peterson, and Doris Garretson, frolicking at the beach in the 1950s.

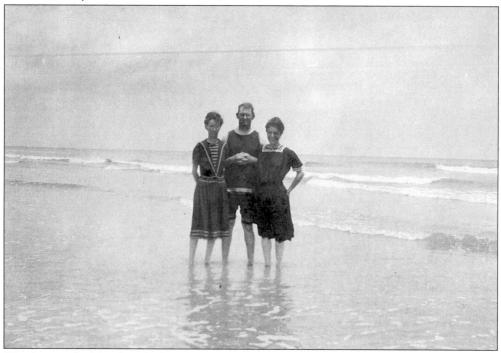

Islanders worked hard and played hard. Here a group shows off the latest in fashionable swimwear as they caper in the surf.

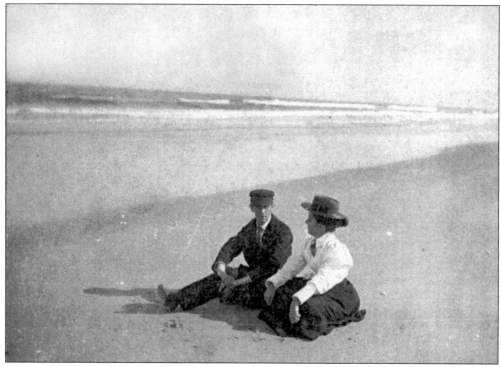

Here is Cocoa Beach when there was plenty of room and when beachgoers wore plenty of clothes.

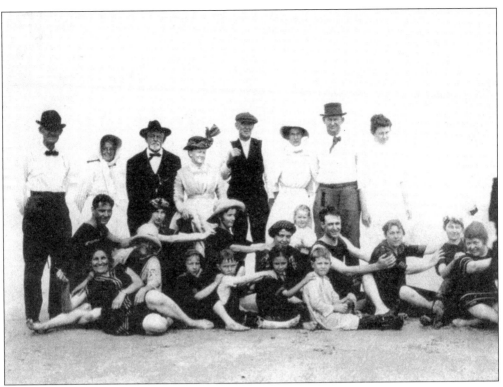

These Merritt Islanders didn't have much need for sunscreen on this outing. The mosquito protection might be another matter! Pictured here, from left to right, are the following: (standing) John Reed, Mr. and Mrs. Sam Field, Mr. and Mrs. ? Gotshall, Mr. and Mrs. Joe Field, and Annie Grant. Among those seated are Mr. ? Jackson, Mrs. ? Abbott, Mattie Buck, Mrs. ? Scott, Mrs. ? Audd, Ethel Field Reed, Jennie Hill, and children.

Few people realize that Charlie Provost was the inspiration for all those Coppertone advertisements seen on billboards everywhere. Here he poses on Cocoa Beach about 1939.

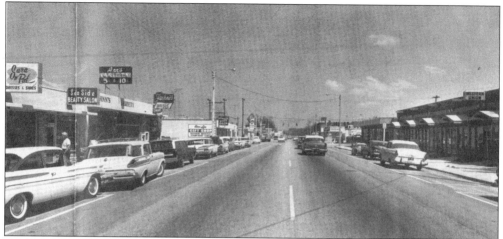

Looking north on Atlantic Avenue—a block east of the Atlantic Ocean–is downtown Cocoa Beach. The "Capitol" of what is sometimes called the "Platinum Coast" or "Space Coast," Cocoa Beach was incorporated in 1925 with Gus Edwards, prominent Brevard County attorney and developer, as its first mayor.

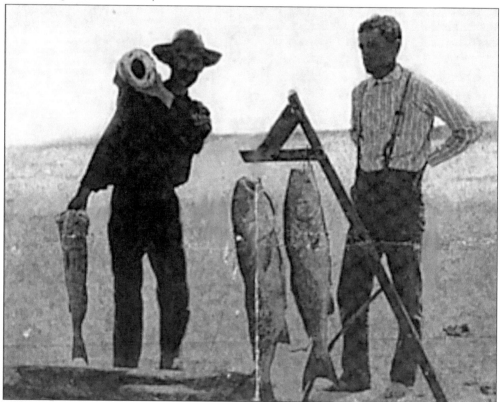

Shown here are sea bass caught at Oceanus (Cocoa Beach) in April 1904 by Jacob Field, of Indianola, and Herbert Constable of Jersey City, New Jersey. The fishermen waded into the surf and cast beyond the breakers. Interestingly, the first bridge from Cocoa to Merritt Island was built in 1917, and the bridge to Cocoa Beach was built in 1923. Therefore, these fishermen passed miles of good fishing in a boat to fish in the ocean.

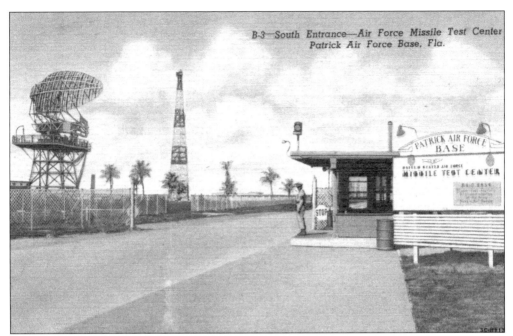

This is the south entrance to Patrick Air Force Base.

This hospital, left from the Banana River Naval Air Station, served the military personnel until it was moved or demolished to make room for a new post office and base exchange.

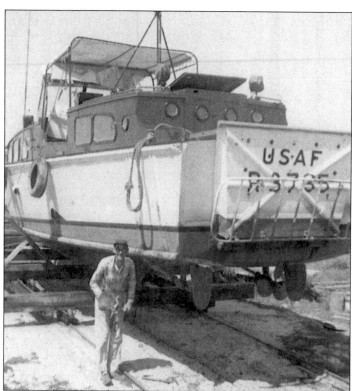

The United States Air Force maintained "crash boats," which were used to recover missile debris at the beginning of the space program. Port Canaveral had not been dredged at that time, so boats were brought into position prior to missile firings.

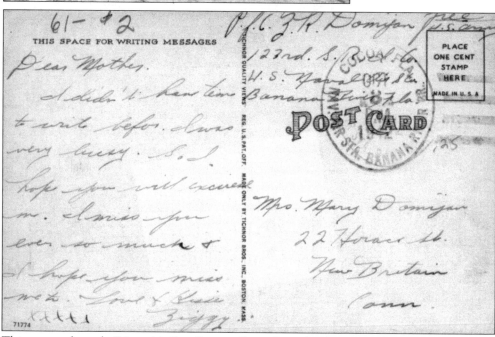

This postmark reads "Nav. Air Sta. Banana River Branch of Cocoa, Fl. Post Office, Oct 3, 1942." Note that there is no stamp on the postcard, just the serviceman's rank and return address. Postage for postcards and letters were free for servicemen and women during times of war. Airmail, however, required postage.

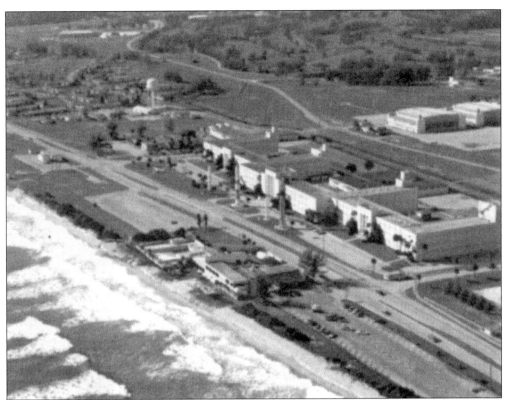

The Patrick Air Force Base "Tech Lab" and NCO Club were located on beachfront. Some display missiles can be seen in front of the "Tech Lab."

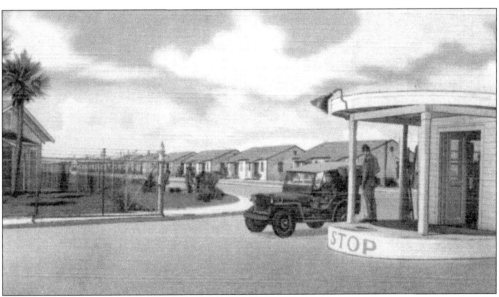

The Banana River Naval Air Station was closed after World War II. The base reopened as the Joint Long Range Proving Grounds, Banana River, Florida. The name later was changed to Patrick Air Force Base.

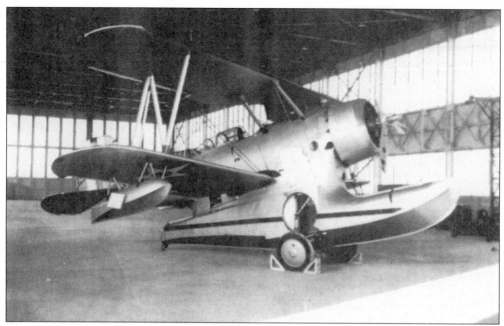

This seaplane was housed in a hanger at Banana River Naval Air Station (now the Patrick Air Force Base). Many of the early planes at Banana River Air Station were seaplanes. Banana River had been dredged to add dirt to the land portion of the base and depth to the river so seaplanes could land there.

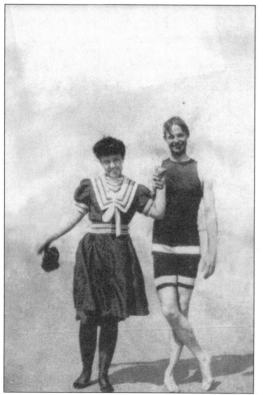

"Oceanus" was the part of the beach that was easiest reached by boat before the bridges were built. "Oceanus" was at the present north boundary of Patrick Air Force Base. This picture features what would have been the latest beachwear at the time.